"I like this place,
And willingly could
waste my time in it."

As You Like It, 2.4

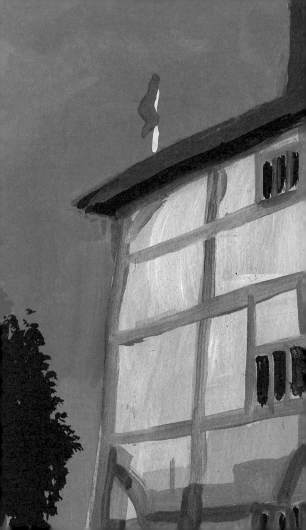

Drawn to the Globe

A Coaster Book
First published in the United Kingdom in 2016
by Ancon Hill Publishing
This paperback edition published in 2016

Ancon Hill Publishing Ltd,
PO Box 68828, London SE26 9BP

A CIP catalogue record for this book is available
from The British Library
Print Book: ISBN 978 0 9574783 4 3

Written, Illustrated, Designed and Typeset by Chris Duggan
Edited by Pete Le May
All quotes by William Shakespeare unless otherwise stated.

Printed and bound by The Printing House,
14 Hanover Street, London W1S 1YH
www.theprintinghouseuk.com

Front cover: Froth from *Measure for Measure*
Back Cover: Joseph Marcell in *King Lear*

For Janet,
for everything

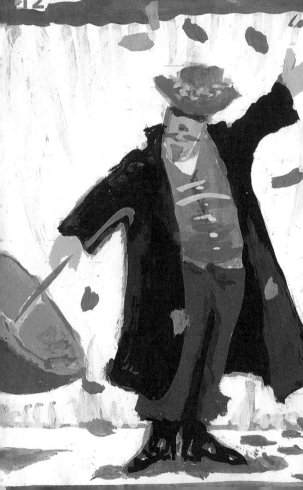

Pictures from
Shakespeare's Globe

DRAWN
GLOBE to the

Chris Duggan

with quotes from
the works of
William Shakespeare

ANCON HILL
PUBLISHING

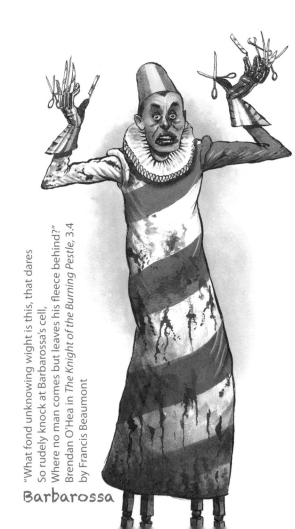

"What fond unknowing wight is this, that dares
So rudely knock at Barbarossa's cell,
Where no man comes but leaves his fleece behind?"
Brendan O'Hea in *The Knight of the Burning Pestle*, 3.4
by Francis Beaumont

Barbarossa

Foreword

e pride ourselves on our variety at the Globe – maybe not infinite as Cleopatra would like to think of herself – but certainly on the way there. Variety of tone, plunging from the searing to the silly; from the tragic to the comic on the turn of an inhaled breath. Shakespeare is most extraordinary for the wonderful burst of different colours he threw across the first Globe stage, and via that across our imaginative history ever since. All human life really is here.

It is the great achievement of these lovely cartoons that they reflect that delicious variety so well. To see Joe Marcell's face etched in pain as King Lear, and then to glance quickly to the bright stripes of Barbarossa in *The Knight of the Burning Pestle*, is to get some measure of what the Globe has been attempting and what Chris Duggan has achieved.

The variety of finish here, from completely rendered substantial images through to whirl of scratching pencil, is also reminiscent of the furious energy of the Globe, the constant sense of new stories whipping and whirling themselves

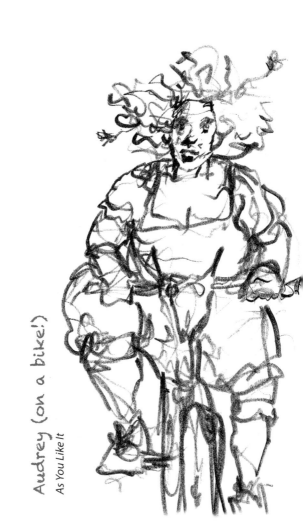

Audrey (on a bike!)
As You Like It

into solidity, and then dissolving into empty space again almost as soon. Stories of great pain and delirious silliness are conjured for an instant in an articulate whirl of motion, and Chris Duggan has caught that rough and frenetic magic beautifully.

We have been very lucky in our recorder.

Dominic Dromgoole
Artistic Director of Shakespeare's Globe 2006-2016

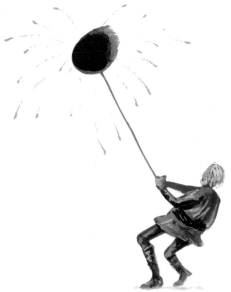

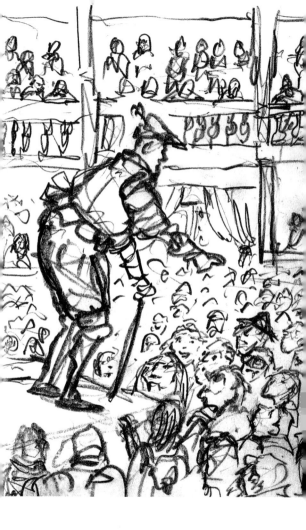

Pardon, gentles all

nter a Groundling. Yes, but what exactly is a groundling? Well, it's a certain fish which lives close to the riverbed such as a catfish or loach, a bottom dweller, and from these lowly creatures came its other meaning as those who stand in the open yard of an Elizabethan theatre. Hamlet mentions them when giving his views on how the players should act, saying, "the groundlings (for the most part) are capable of nothing but inexplicable dumb shows and noise." This was a friendly jibe at the poorer Londoner who could only afford a penny in the yard and not a seat in the gallery.

Shakespeare was from a modest background himself and he wrote for and about the common man as much as the noble and aristocratic. The fish metaphor is rather apt for the shoal of groundlings, standing level with the actors' ankles, gaping up at the stage.

Our parents introduced my brother Tony and me to Shakespeare in the late sixteenth century. At least it feels like that. We stumbled across a production of *Hamlet* (or was it *Macbeth*?) acted on the back of a cart in the yard of the George Inn, on Borough High Street in Southwark, the last

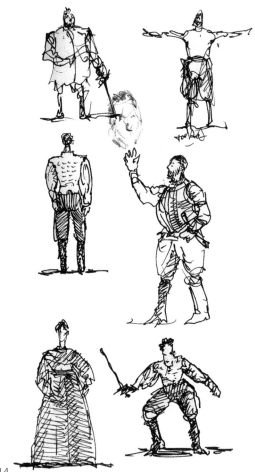

galleried coaching inn in London, not far from the Globe Theatre. The scene may easily have echoed Shakespeare's own introduction to the stage, an experience familiar to many Elizabethan playgoers – the audience crowded around a makeshift stage in an inn yard, with the more affluent viewing from the galleries. The set up was so practical the inns might have been designed for that reason, and the first purpose-built English theatres adopted a similar plan.

Another early brush with the Bard was at the Academy Cinema (sadly no more) in London's Oxford Street which held a Laurence Olivier Shakespeare Season every year; *Henry V, Othello, Hamlet* and the ever-popular *Richard III*. I can't say I knew what was going on most of the time, but the characters, the colours, the heroic speeches and, of course, the battles had me hooked!

This pleasant, nodding acquaintanceship with Mr. S. continued until 1996 when, thanks to the efforts of the American actor, director and producer Sam Wanamaker, the Globe Theatre miraculously reappeared on Bankside (the south bank of the Thames between Blackfriars and London Bridges) nearly 400 years after the first was built.

Seeing Shakespeare at the Globe is a revelation. It starts in party mood, food sellers wander around with drinks and snacks. The

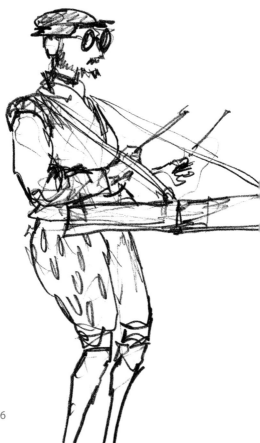

playgoers take in the atmosphere, talking, laughing, eating, sitting on the ground resting their legs if they are in the yard or hiring a cushion and finding their seats in the three tiers of galleries while the performance bell rings out. The music may have started already, played live by musicians often on instruments that would have been familiar to Shakespeare's audience. As they fade away the play drifts in. Sometimes the actors may have a friendly word with the audience as they walk through them, or at the edge of the stage. You hardly have time to think, this is where I must start to work, to try and decipher the conundrum of Shakespearean language. If this sort of thing worries you it's good to remember Shakespeare is, after all, talking in English, and he's using (sometimes inventing) many of the idioms that we all use from day to day. It's just the richness of the language that is less familiar to us.

The first Globe held afternoon performances, with its open roof letting in the daylight, illuminating the actors and audience equally. There were usually no evening performances – the cost of lighting such a large arena would have been prohibitive and the journey home too dangerous, if not impossible with the city gates closed on London Bridge, which other than the wherries, a kind of river taxi, was the only crossing

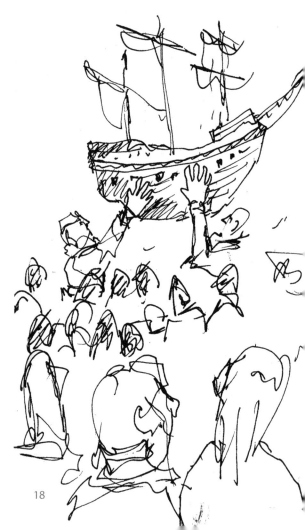

at the time. Today's Globe does hold evening shows, but there is no dimming of the house lights – the actors can see everybody in the audience and draw them into the action. Before you know it, you are drawn in and carried away in the story. Shakespeare asks us to use our imaginations, ("Piece out our imperfections with your thoughts..."), to see what is described in the mind's eye, the forests, the castles, the battles, the rough seas and the storms. He often makes reference to the 'conspiracy' between the players and audience in accepting the artifice of the play and the playhouse itself: "...this wooden O" in *Henry V*, "...the great globe itself..." in *The Tempest* referring to the world but also the world in microcosm in the Globe Theatre, or even reference to the neighbouring Rose Theatre with its dodgy drainage, "That which we call a rose / by any other name would smell as sweet" might have got an extra laugh in Shakespeare's day.

There are, of course, always opportunities to see Shakespeare performed in so many brilliant productions in theatres around the world and he owes much to the legion of masterful interpreters of his work through the ages, but hearing the plays on their 'home' ground is to find not a theme-park experience but something of the original Shakespeare. Shakespeare 'unplugged', Shakespeare revealed and explained. I was

hooked again.

Without any conscious intent, and at risk of sounding like some bardic trainspotter, I find I have seen every production of Shakespeare at the Globe. Seeing one led me on to see another. It was easy and always a pleasure. The nearness of the actors and the feeling of inclusion in the action and reactions of my fellow playgoers, their wonder, joy, sympathy and involvement is an integral part of the Globe. The several hundred people standing in the yard provide the Globe with a huge cast unavailable to other theatres. They might be the forests or the seas, sometimes they are the townsfolk, the citizens, the courtiers, the mobs and the armies, to whom the desperate appeals or the stirring speeches are directed. The modern audience very soon fell into the ways of their forebears with an inspired groundling shouting out, "We're right behind you, 'Enry!" following one of the rallying speeches delivered by Mark Rylance as Henry V.

I always have my sketch book (about the same size as the book you are holding) with me to record anything interesting wherever I am and of course the Globe drawings grew to quite a number. Just little sketches, memory-joggers, and there was always plenty of memorable stuff. The transformation of the theatre into a fully rigged ship on a stormy ocean full of acrobatic sailors in

Pericles. Or the ship in miniature carried through the aforementioned 'sea of groundlings', the players on stage reflecting that same deck in the stormy opening of *The Tempest*. Or the triumphal procession of the eponymous, victorious Titus Andronicus, his grand progress preceded by crowd-controlling Roman soldiers and strewn with rose petals and fainting groundlings (well, it was a shockingly violent production). Or the sinister crows falling from the sky in *Timon of Athens*. Or the tiny moments of pathos – the rejected Falstaff in *Henry IV Part 2*, or the tragic fatal denouement of *Romeo and Juliet* – when you could hear a pin drop. And through it all, broiling sun, downpours of hail, driving rain, and helicopters passing overhead, the groundlings stand transfixed, desperate to know how it all turns out. At the end of the show another Globe phenomenon invariably takes place – an enormous cheer from the 1600-strong audience, whoops and whistles more at home at a rock concert than a theatre. They're cheering not just the play and the miracle that these words still touch us, even 'explain us' to ourselves and each other, their power undiminished after 400 years, but also to celebrate the shared experience of audience and players in "the two hours' traffic of our stage..." They are drawn into the drama, a sea of faces bobbing in the yard like those groundling

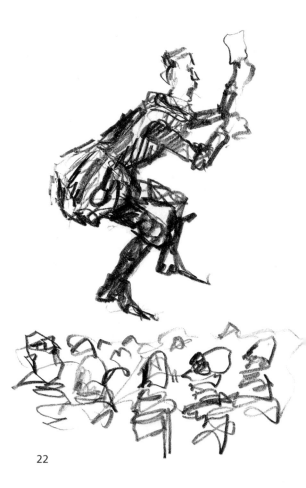

fish at feeding time and all, like me, happy to be hooked.

Most of the pictures in this book were made from memory in the interval, at the end of the show or in the following days, as I'm sure my fellow groundlings wouldn't want the distraction of me drawing during the performance or the added discomfort of my elbowing them in the ribs, let alone the fact that I'd be missing the action. So all in all I prefer to draw 'after the act'. I have used some photographic reference for those pictures with named actors to ensure a likeness.

The name of the character is given on every page in alphabetical order. The name of the play follows the quote with the act and scene number. For 'Globe to Globe' productions, which were presented by international companies in their own language ("...acted over in states unborn and accents yet unknown." *Julius Caesar*), the country of origin is given after the play title.

Despite its diminutive size (more coaster than coffee-table), this book has been nearly 20 years in the making! It's my personal view of the Globe which I hope the reader will enjoy in its own right. But who knows, you may feel 'drawn in' as I was and perhaps inspired to rent a cushion and buy a seat or else just dive in with the other groundlings in the yard and experience a unique glimpse into Shakespeare's world.

Chris Duggan

" O for a Muse of fire, that would ascend
The brightest heaven of invention:
A kingdom for a stage, princes to act
And monarchs to behold the swelling scene.
Then should the warlike Harry, like himself,
Assume the port of Mars, and at his heels,
Leashed in like hounds, should famine, sword and fire
Crouch for employment. But pardon, gentles all,
The flat unraised spirits that have dared
On this unworthy scaffold to bring forth
So great an object. Can this cock-pit hold
The vasty fields of France? Or may we cram
Within this wooden O the very casques
That did affright the air at Agincourt?
O, pardon: since a crooked figure may
Attest in little place a million,
And let us, ciphers to this great account,
On your imaginary forces work.
Suppose within the girdle of these walls
Are now confined two mighty monarchies,
Whose high upreared and abutting fronts
The perilous narrow ocean parts asunder.
Piece out our imperfections with your thoughts:
Into a thousand parts divide one man,
And make imaginary puissance.
Think when we talk of horses, that you see them
Printing their proud hoofs i' th' receiving earth;
For 'tis your thoughts that now must deck our kings,
Carry them here and there, jumping o'er times,
Turning the accomplishment of many years
Into an hourglass – for the which supply,
Admit me Chorus to this history,
Who prologue-like your humble patience pray,
Gently to hear, kindly to judge, our play."

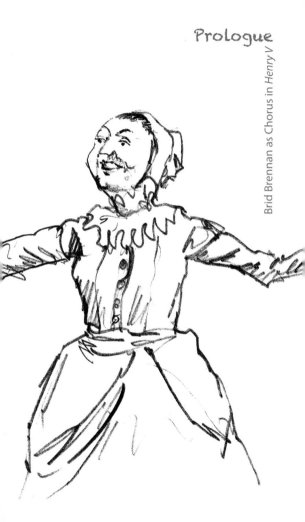

Brid Brennan as Chorus in *Henry V*

Achilles, Patroclus, Thersites

"Agamemnon is a fool to offer to command Achilles;
Achilles is a fool to be commanded of Agamemnon;
Thersites is a fool to serve such a fool, and
Patroclus is a fool positive."
Troilus and Cressida, 2.3

Adam

"I have five hundred crowns...
Which I did store to be my foster-nurse,
When service should in my old limbs lie lame,
And unregarded age in corners thrown.
Take that, and He that doth the ravens feed,
Yea, providently caters for the sparrow,
Be comfort to my age!"
As You Like It, 2.4

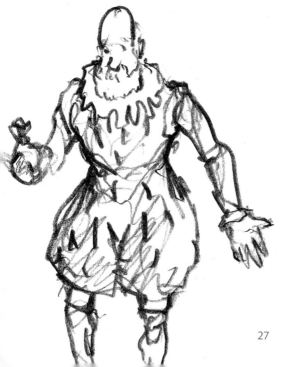

"Alas, poor world, what treasure hast thou lost.
What face remains alive that's worth the viewing?
Whose tongue is music now? what canst thou boast
Of things long since, or any thing ensuing?
The flowers are sweet, their colours fresh and trim;
But true sweet beauty lived and died with him."

Venus and Adonis, 1075

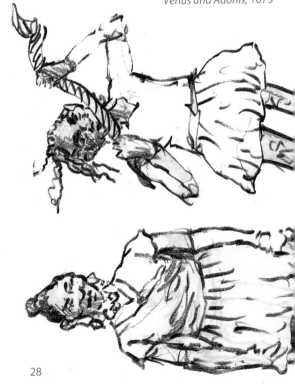

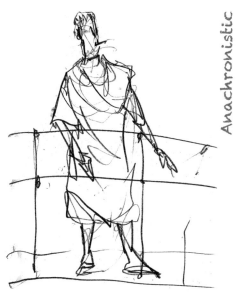

During the interval of *Julius Caesar*, that most anachronistic of plays with clocks chiming, doublets with pockets, and books to entertain the pedant, I was pleased to discover a be-toga'd Roman enjoying a crafty cigarette near the stage door.

Of course, Shakespeare's continued success is in no small part thanks to the brilliant reinterpretations of the work and a modern audience would find it quite acceptable if Brutus wore a suit or Caesar drove a car. But, still, the cigarette and toga seemed so incongrous I felt it worth including.

Inhale, mighty Caesar?

29

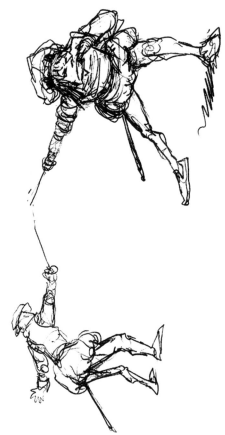

Sir Andrew Aguecheek

"Plague on't, an I thought he had been valiant and so cunning in fence, I'd have seen him damned ere I'd have challenged him." *Twelfth Night*, 3.4

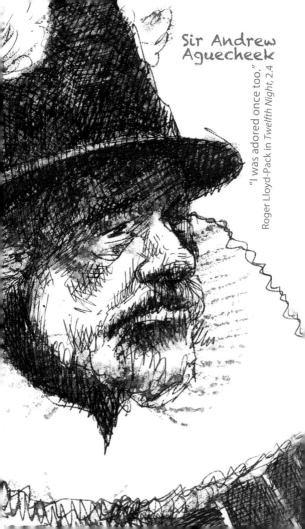

Sir Andrew
Aguecheek

"I was adored once too."
Roger Lloyd-Pack in *Twelfth Night*, 2.4

Angelo

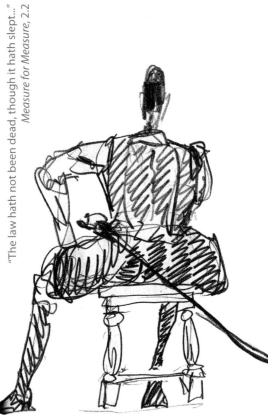

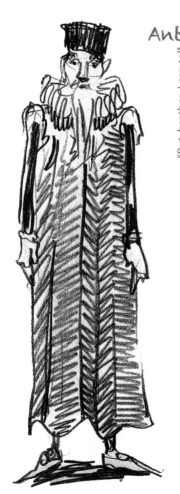

Antonio

"But, brother, I can tell
you strange news that
you yet dreamt not of."
Much Ado About Nothing, 1.2

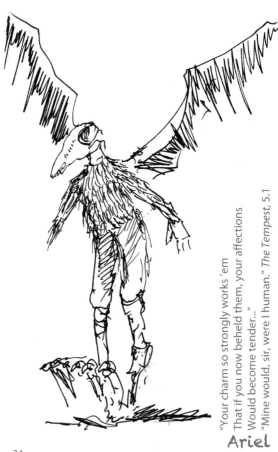

"Your charm so strongly works 'em
That if you now beheld them, your affections
Would become tender..."
"Mine would, sir, were I human." *The Tempest*, 5.1

Ariel

"...my face does you no harm."
Henry IV Part 1, 3.3

Bardolph

Bharatram (Bertram)

"A heaven on earth I have won by wooing thee."
Chirag Vora in *All's Well That Ends Well*, 4.2 (India)

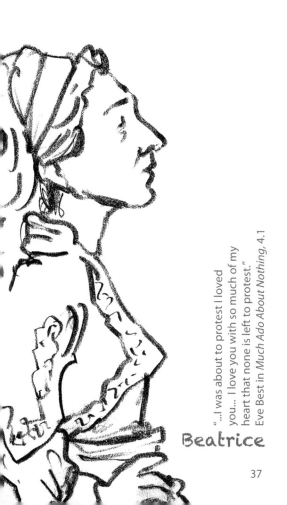

"...I was about to protest I loved you... I love you with so much of my heart that none is left to protest."
Eve Best in *Much Ado About Nothing*, 4.1

Beatrice

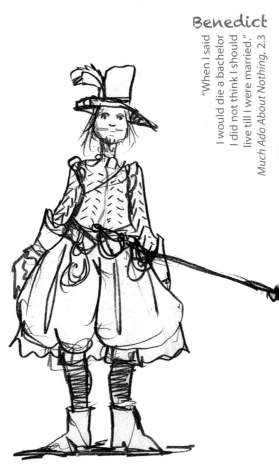

"When I said
I would die a bachelor
I did not think I should
live till I were married."
Much Ado About Nothing, 2.3

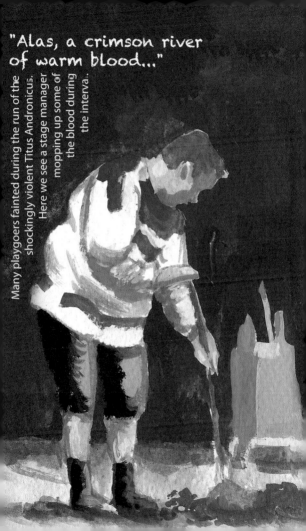

"Alas, a crimson river of warm blood..."

Many playgoers fainted during the run of the shockingly violent Titus Andronicus. Here we see a stage manager mopping up some of the blood during the interva.

Bottom

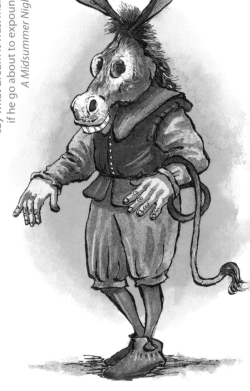

"I have had a dream, past the wit of man to say what dream it was. Man is but an ass, if he go about to expound this dream."
A Midsummer Night's Dream, 4.1

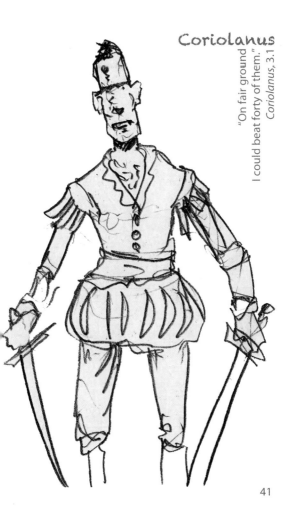

Coriolanus

"On fair ground
I could beat forty of them."
Coriolanus, 3.1

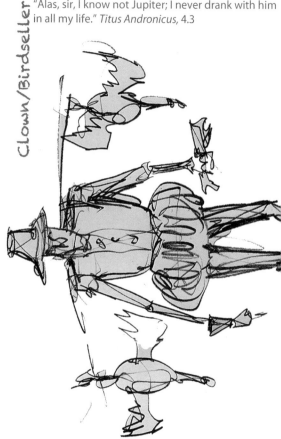

Clown/Birdseller

"Alas, sir, I know not Jupiter; I never drank with him in all my life." *Titus Andronicus*, 4.3

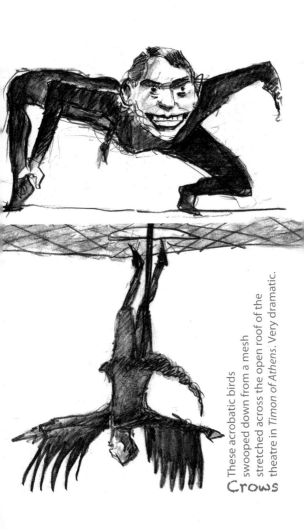

These acrobatic birds swooped down from a mesh stretched across the open roof of the theatre in *Timon of Athens*. Very dramatic.

Crows

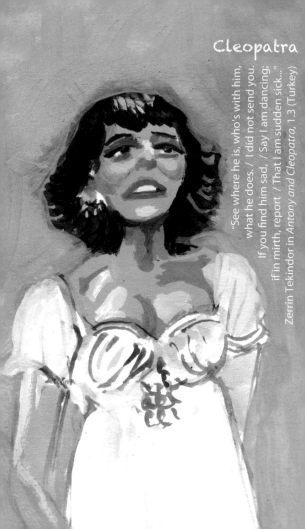

Cleopatra

"See where he is, who's with him, what he does. / I did not send you. If you find him sad, / Say I am dancing; if in mirth, report / That I am sudden sick..."
Zerrin Tekindor in Antony and Cleopatra, 1.3 (Turkey)

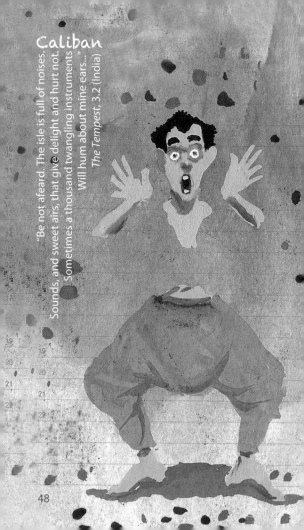

Caliban

"Be not afeard. The isle is full of noises,
Sounds, and sweet airs, that give delight and hurt not.
Sometimes a thousand twangling instruments
Will hum about mine ears..."
The Tempest, 3.2 (India)

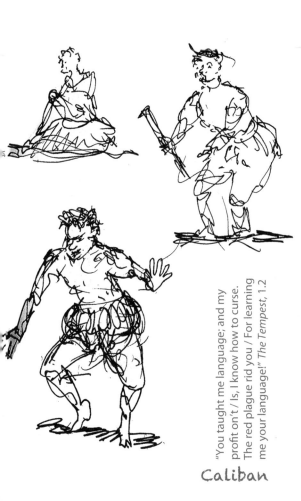

"You taught me language; and my profit on't / Is, I know how to curse. The red plague rid you / For learning me your language!" *The Tempest*, 1.2

Caliban

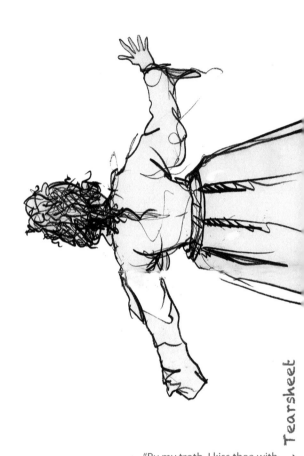

"By my troth, I kiss thee with a most constant heart."
Henry IV Part 2, 2.4

Doll Tearsheet

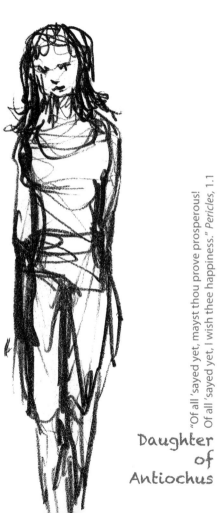

"Of all 'sayed yet, mayst thou prove prosperous!
Of all 'sayed yet, I wish thee happiness." *Pericles*, 1.1

Daughter
of
Antiochus

Dromio

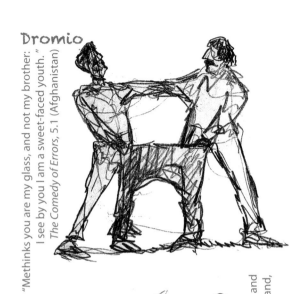

"Methinks you are my glass, and not my brother:
I see by you I am a sweet-faced youth."
The Comedy of Errors, 5.1 (Afghanistan)

"We came into the world like brother and
brother, / And now let's go hand in hand,
not one before another."

Dromio

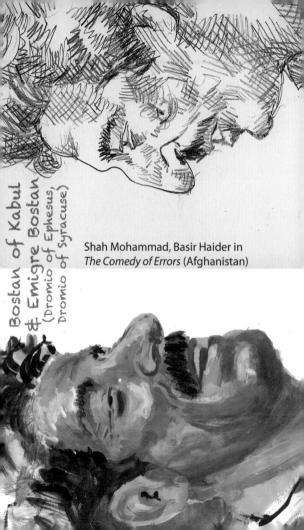

Bostan of Kabul
& Emigre Bostan
(Dromio of Ephesus,
Dromio of Syracuse)

Shah Mohammad, Basir Haider in
The Comedy of Errors (Afghanistan)

Dogberry

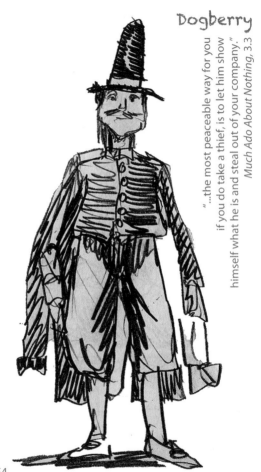

"...the most peaceable way for you if you do take a thief, is to let him show himself what he is and steal out of your company."
Much Ado About Nothing, 3.3

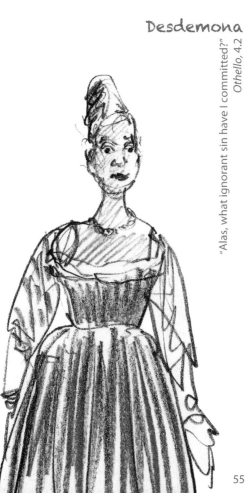

Desdemona

"Alas, what ignorant sin have I committed?"
Othello, 4.2

Death

"Do I delight to die, or life desire?
But now I lived, and life was death's annoy,
But now I died, and death was lively joy."
Venus and Adonis, 496-8

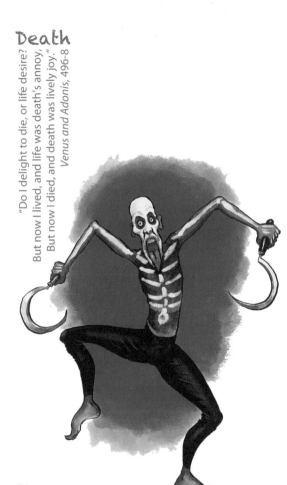

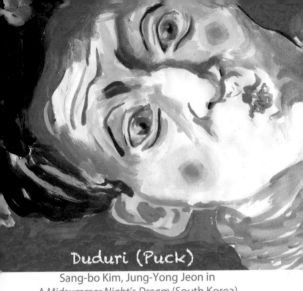

Duduri (Puck)

Sang-bo Kim, Jung-Yong Jeon in
A Midsummer Night's Dream (South Korea)

"And, like a jolly troop of huntsmen, come
Our lusty English, all with purpled hands,
Dyed in the dying slaughter of their foes.
Open your gates and give the
victors way."
King John, 2.1 (Armenia)

English Herald

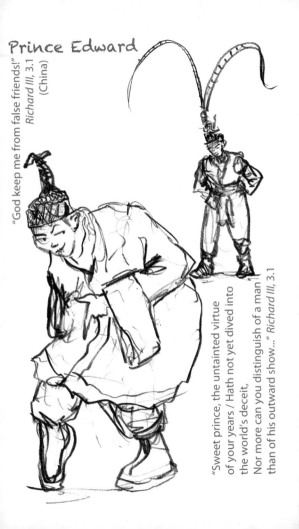

Prince Edward

(China)

"God keep me from false friends!"
Richard III, 3.1

"Sweet prince, the untainted virtue
of your years / Hath not yet dived into
the world's deceit,
Nor more can you distinguish of a man
than of his outward show..." *Richard III*, 3.1

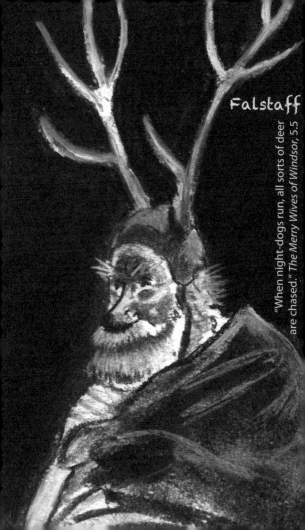

Falstaff

"When night-dogs run, all sorts of deer are chased." *The Merry Wives of Windsor*, 5.5

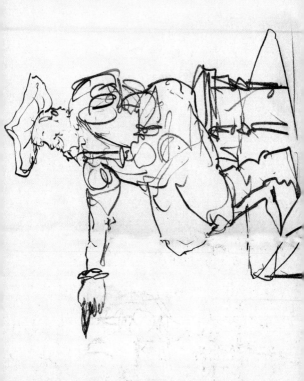

Falstaff

"...there is virtue in that Falstaff.
Him keep with, the rest banish. "
Henry IV Part 1, 2.5

61

Falstaff

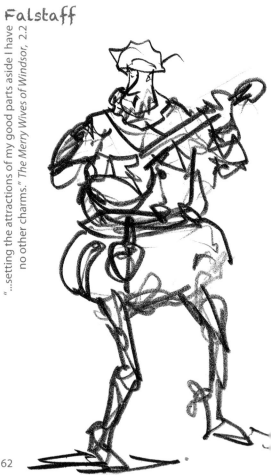

"...setting the attractions of my good parts aside I have no other charms." *The Merry Wives of Windsor*, 2.2

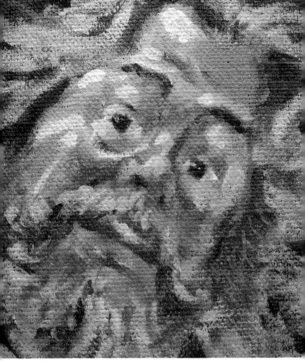

Falstaff

"What is honour? A word. What is in that word
honour? What is that honour? Air. A trim reckoning!
Who hath it? He that died o' Wednesday. Doth he
feel it? No. Doth he hear it? No.'Tis insensible, then?
Yea, to the dead. But will it not live with the living?
No. Why? Detraction will not suffer it. Therefore I'll
none of it. Honour is a mere scutcheon: and so
ends my catechism."
Roger Allam in *Henry IV Part 1*, 5.1

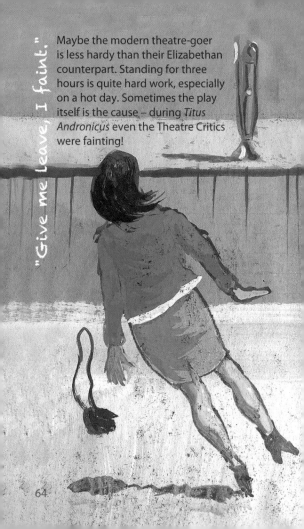

Maybe the modern theatre-goer is less hardy than their Elizabethan counterpart. Standing for three hours is quite hard work, especially on a hot day. Sometimes the play itself is the cause – during *Titus Andronicus* even the Theatre Critics were fainting!

"Give me leave, I faint."

Fluellen

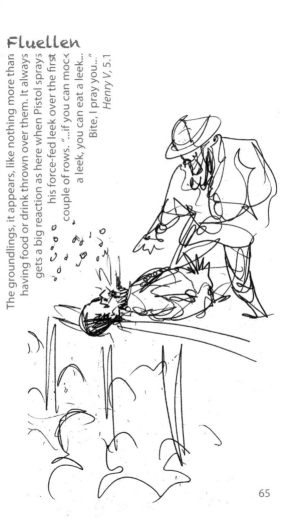

The groundlings, it appears, like nothing more than having food or drink thrown over them. It always gets a big reaction as here when Pistol sprays his force-fed leek over the first couple of rows. "...if you can mock a leek, you can eat a leek...

Bite, I pray you..."
Henry V, 5.1

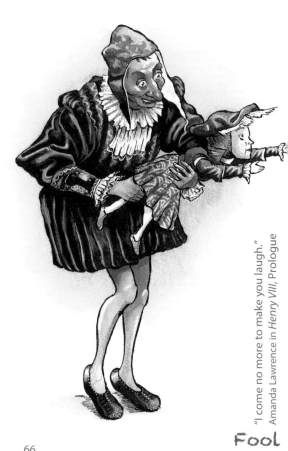

"I come no more to make you laugh."
Amanda Lawrence in *Henry VIII*, Prologue

Fool

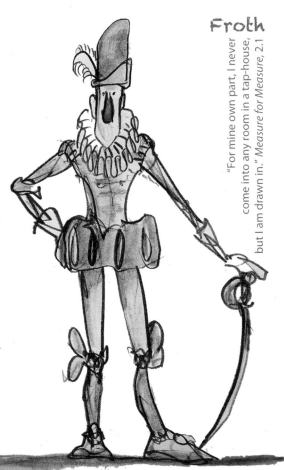

Froth

"For mine own part, I never come into any room in a tap-house, but I am drawn in." *Measure for Measure*, 2.1

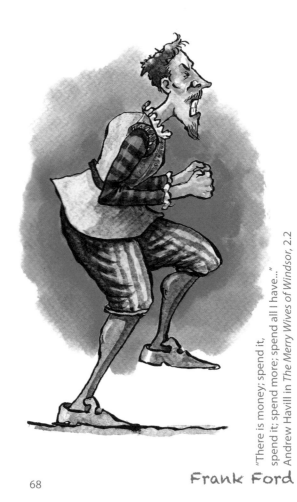

"There is money; spend it, spend it; spend more; spend all I have..." Andrew Havill in *The Merry Wives of Windsor*, 2.2

Frank Ford

Ghost of Hamlet,
King of Denmark

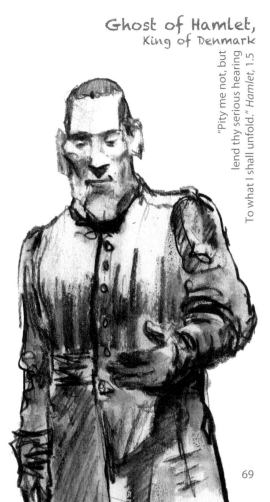

"Pity me not, but
lend thy serious hearing
To what I shall unfold." *Hamlet*, 1.5

Ghost

"I could a tale unfold whose lightest word
Would harrow up thy soul, freeze thy young blood,
Make thy two eyes, like stars, start from their spheres..." *Hamlet*, 1.5

70

Gloucester

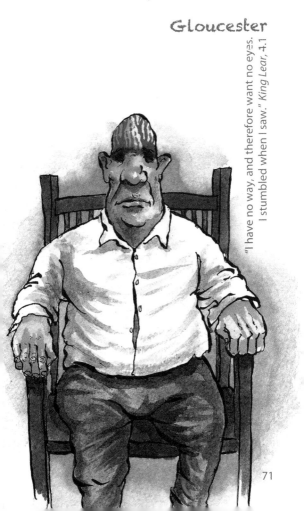

"I have no way, and therefore want no eyes. I stumbled when I saw." *King Lear*, 4.1

Gokaldas (King of France)

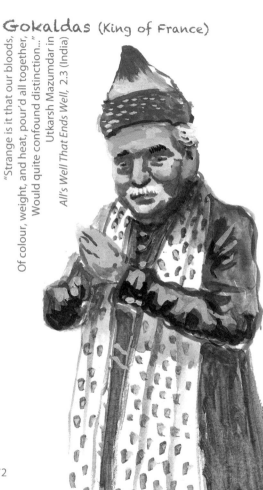

"Strange is it that our bloods,
Of colour, weight, and heat, pour'd all together,
Would quite confound distinction..."
Utkarsh Mazumdar in
All's Well That Ends Well, 2.3 (India)

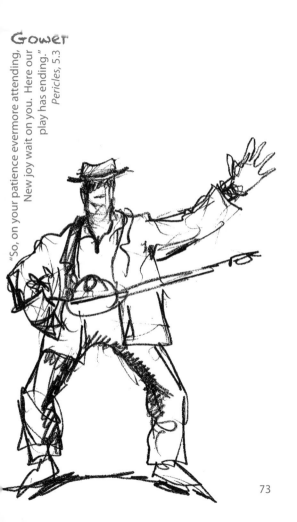

Gower

"So, on your patience evermore attending,
New joy wait on you. Here our
play has ending."

Pericles, 5.3

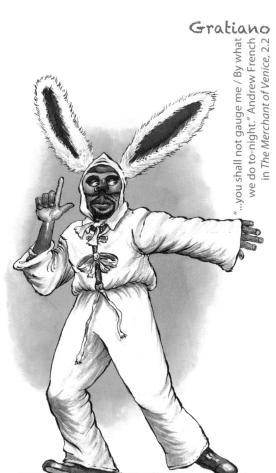

Gratiano

"...you shall not gauge me / By what we do to-night." Andrew French in *The Merchant of Venice*, 2.2

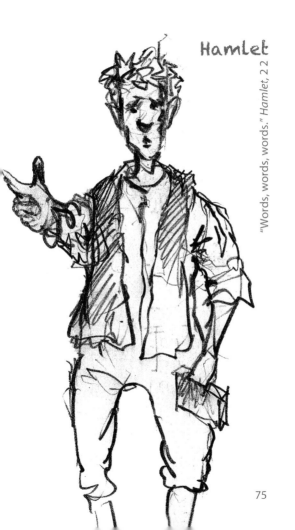

Hamlet

"Words, words, words." *Hamlet*, 2 2

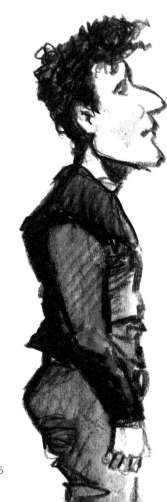

"What a piece of work is a man! How noble in reason, how infinite in faculty, in form and moving how express and admirable, in action how like an angel, in apprehension how like a god – the beauty of the world, the paragon of animals! And yet to me what is this quintessence of dust? Man delights not me – no, nor woman neither..." Joshua McGuire in *Hamlet*, 2.2

Hamlet

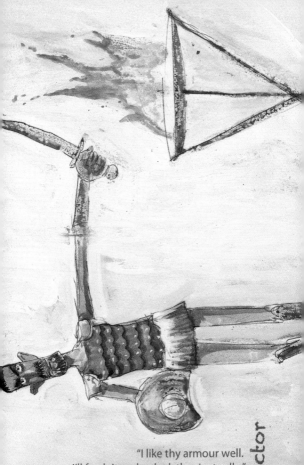

"I like thy armour well.
I'll frush it and unlock the rivets all..."
Troilus and Cressida, 5.6

Hector

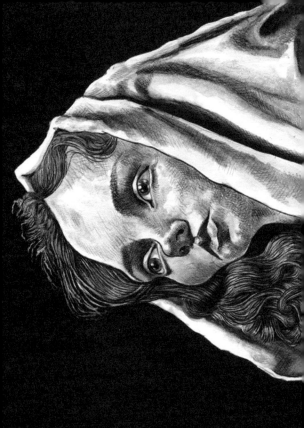

Helen

Lily Cole in *The Last Days of Troy*
by Simon Armitage

78

Prince Henry

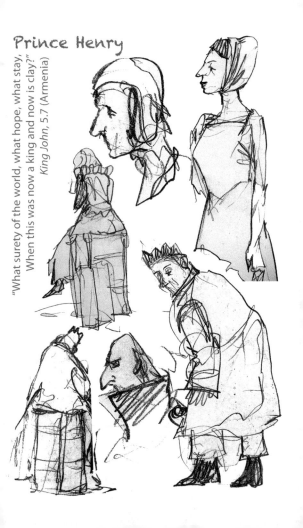

"What surety of the world, what hope, what stay,
When this was now a king and now is clay?"
King John, 5.7 (Armenia)

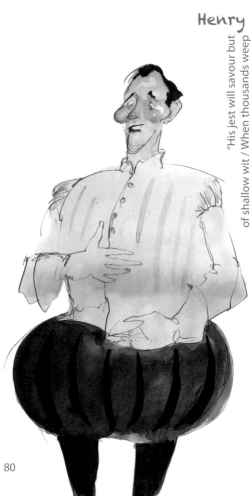

Henry V

"His jest will savour but of shallow wit / When thousands weep more than did laugh at it." Mark Rylance in *Henry V*, 1.2

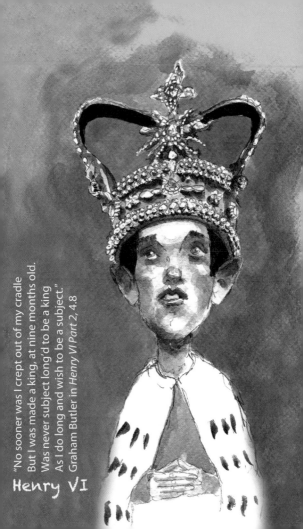

"No sooner was I crept out of my cradle
But I was made a king, at nine months old.
Was never subject long'd to be a king
As I do long and wish to be a subject."
Graham Butler in *Henry VI Part 2, 4.8*

Henry VI

Henry VI

"Was ever king that joy'd an earthly throne,
And could command no more content than I?"
Henry VI Part 2, 4.9

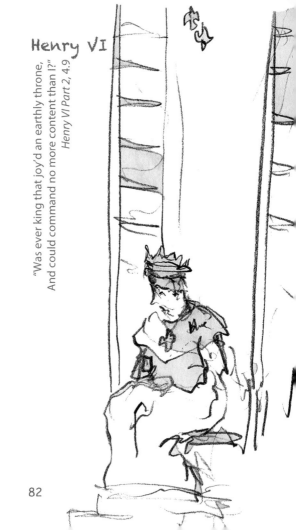

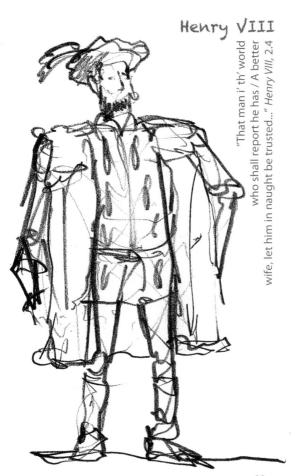

Henry VIII

"That man i' th' world who shall report he has / A better wife, let him in naught be trusted..." *Henry VIII*, 2.4

Hero

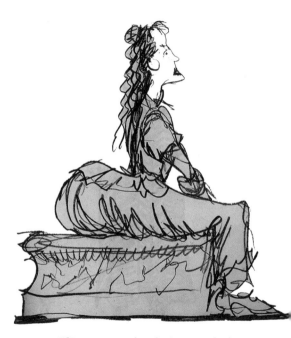

"If it proves so, then loving goes by haps.
Some Cupid kills with arrows, some with traps."
Much Ado About Nothing, 3.1

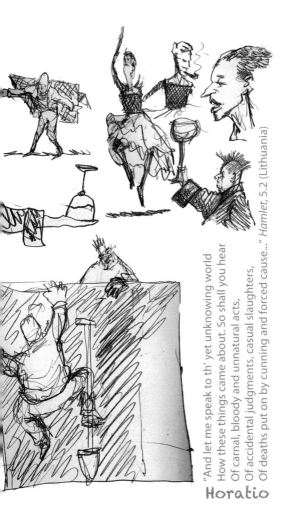

"And let me speak to th' yet unknowing world
How these things came about. So shall you hear
Of carnal, bloody and unnatural acts,
Of accidental judgments, casual slaughters,
Of deaths put on by cunning and forced cause..." *Hamlet*, 5.2 (Lithuania)

Horatio

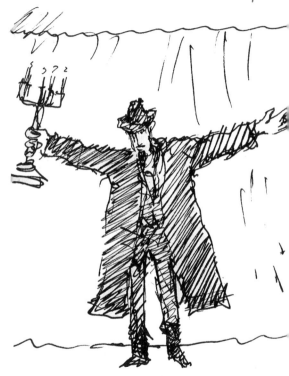

Jaques

"By my troth, I was seeking for a fool when I found you."
As You Like It, 3.2 (Georgia)

Joan La Pucelle
(Joan of Arc)

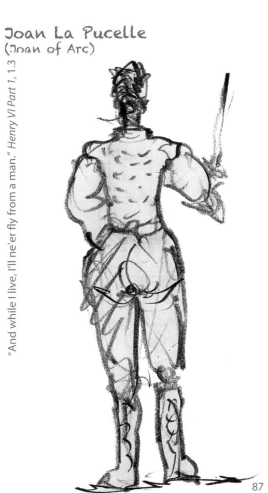

"And while I live, I'll ne'er fly from a man." *Henry VI Part 1*, 1.3

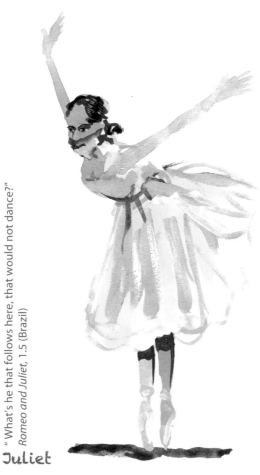

"What's he that follows here, that would not dance?"
Romeo and Juliet, 1.5 (Brazil)

Juliet

Juliet
"My only love sprung from my only hate!
Too early seen unknown, and known too late!
Prodigious birth of love it is to me,
That I must love a loathed enemy."
Ellie Kendrick in *Romeo and Juliet*, 1.5

Mark Antony

"This was the most unkindest cut of all.
For when the noble Caesar saw him stab,
Ingratitude, more strong than traitors' arms,
Quite vanquish'd him. Then burst his mighty heart,
And, in his mantle muffling up his face,
Even at the base of Pompey's statue,
Which all the while ran blood, great Caesar fell.
O, what a fall was there, my countrymen!
Then I, and you, and all of us fell down,
Whilst bloody treason flourished over us."
Julius Caesar, 3.2 (Italy)

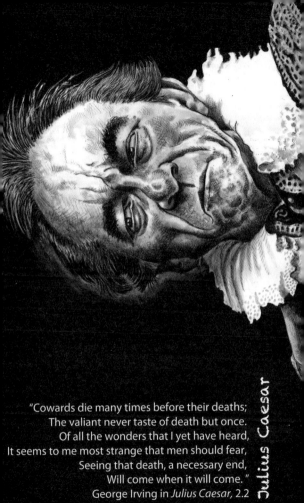

"Cowards die many times before their deaths;
The valiant never taste of death but once.
Of all the wonders that I yet have heard,
It seems to me most strange that men should fear,
Seeing that death, a necessary end,
Will come when it will come. "
George Irving in *Julius Caesar*, 2.2

Julius Caesar

Queen Katherine

"Like the lily,
That once was mistress of the field and flourished,
I'll hang my head and perish."
Henry VIII, 3.1

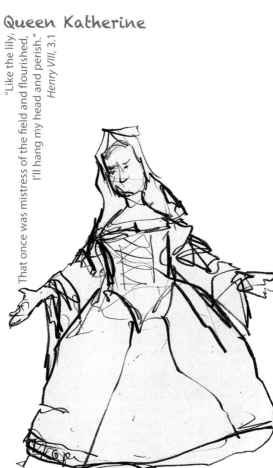

92

"You are a saucy fellow.
Deserve we no more reverence?" *Henry VIII*, 4.2

"They call me Katherine that do talk of me."
"You lie, in faith, for you are called plain Kate..."
The Taming of the Shrew, 2.1

Katherine, Petruchio

King John

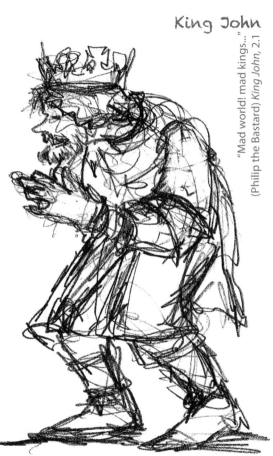

"Mad world! mad kings..."
(Philip the Bastard) *King John*, 2.1

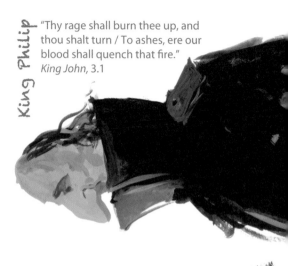

King Philip

"Thy rage shall burn thee up, and thou shalt turn / To ashes, ere our blood shall quench that fire." *King John*, 3.1

King John

"How oft the sight of means to do ill deeds makes ill deeds done!" *King John*, 4.2 (Armenia)

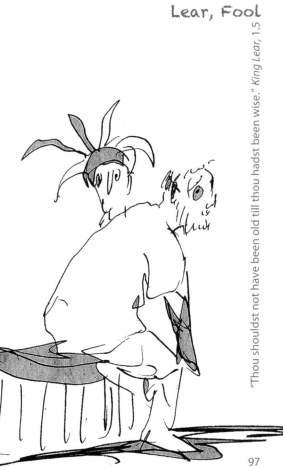

"Thou shouldst not have been old till thou hadst been wise." *King Lear*, 1.5

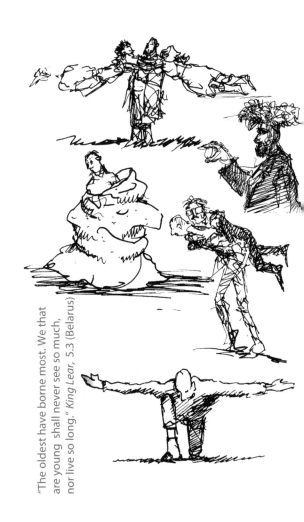

"The oldest have borne most. We that are young shall never see so much, nor live so long." *King Lear*, 5.3 (Belarus)

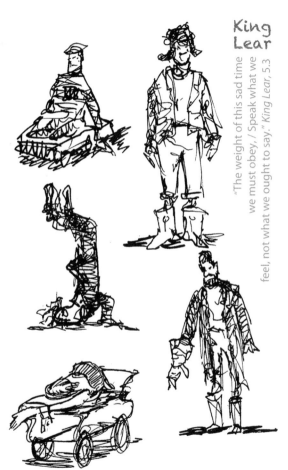

King Lear

"The weight of this sad time we must obey, / Speak what we feel, not what we ought to say." *King Lear*, 5.3

99

King Lear

"Which of you shall we say doth love us most?
King Lear, 1.1 Belarus

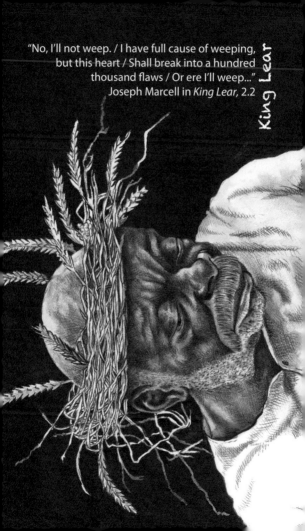

"No, I'll not weep. / I have full cause of weeping, but this heart / Shall break into a hundred thousand flaws / Or ere I'll weep..."
Joseph Marcell in *King Lear*, 2.2

King Lear

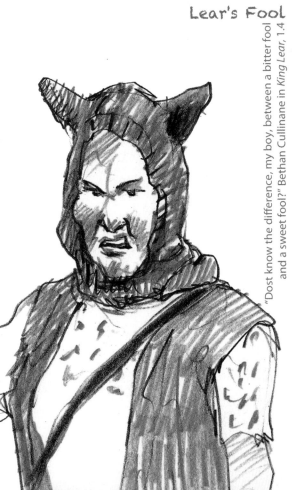

Lear's Fool

"Dost know the difference, my boy, between a bitter fool and a sweet fool?" Bethan Cullinane in *King Lear*, 1.4

Kunti (Countess of Roussillon)

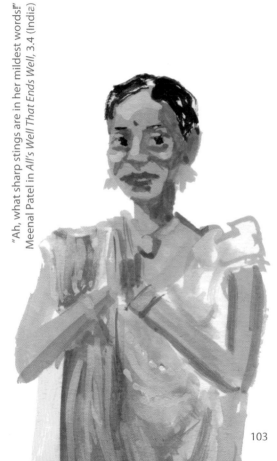

"Ah, what sharp stings are in her mildest words!"
Meenal Patel in *All's Well That Ends Well*, 3.4 (India)

103

Lady Capulet

"Talk not to me, for I'll not speak a word.
Do as thou wilt, for I have done with thee."
Romeo and Juliet, 3.5

Lady Capulet

"...some grief shows much of love,
But much of grief shows still some want of wit."
Romeo and Juliet, 3.5 (Brazil)

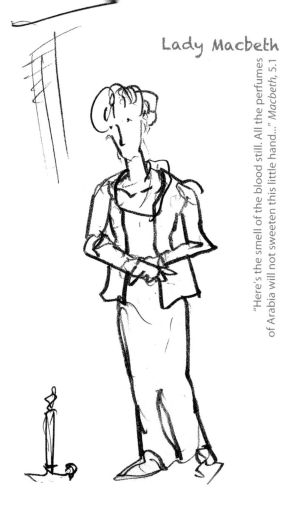

Lady Macbeth

"Here's the smell of the blood still. All the perfumes of Arabia will not sweeten this little hand..." *Macbeth*, 5.1

Lady Macbeth

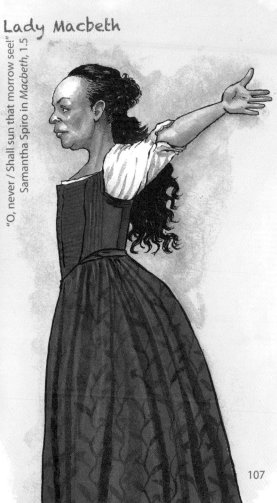

"O, never / Shall sun that morrow see!" Samantha Spiro in *Macbeth*, 1.5

107

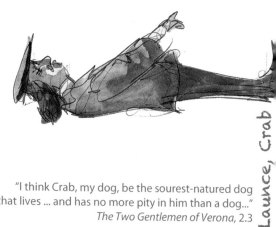

Launce, Crab

"I think Crab, my dog, be the sourest-natured dog
that lives ... and has no more pity in him than a dog..."
The Two Gentlemen of Verona, 2.3

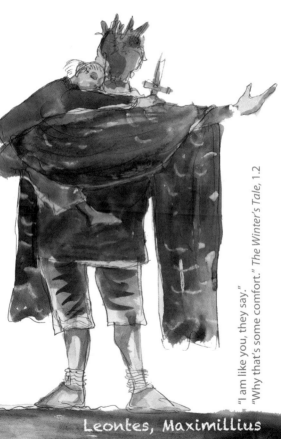

"I am like you, they say."
"Why that's some comfort." *The Winter's Tale,* 1.2

Leontes, Maximillius

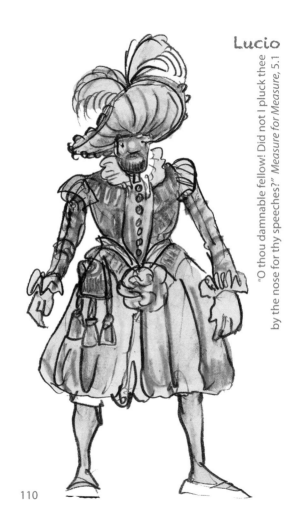

Lucio

"O thou damnable fellow! Did not I pluck thee by the nose for thy speeches?" *Measure for Measure*, 5.1

Lysimachus

"I did not think / Thou couldst have spoke so well; ne'er dreamt thou couldst. / Though I brought hither a corrupted mind, Thy speech hath altered it..." *Pericles*, 4.6

111

Macbeth

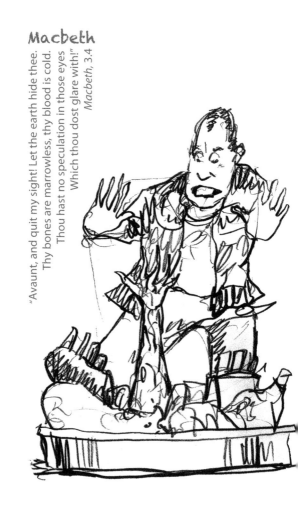

"Avaunt, and quit my sight! Let the earth hide thee.
Thy bones are marrowless, thy blood is cold.
Thou hast no speculation in those eyes
Which thou dost glare with!"
Macbeth, 3.4

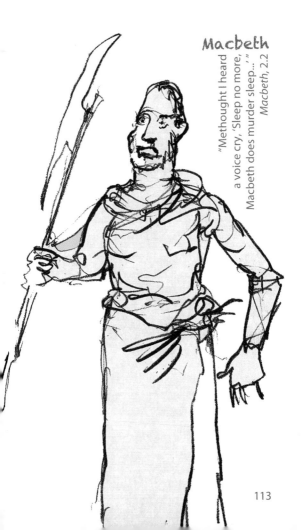

Macbeth

"Methought I heard
a voice cry, 'Sleep no more,
Macbeth does murder sleep...' "
Macbeth, 2.2

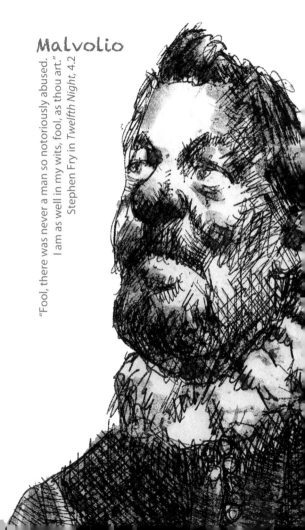

Malvolio

"Fool, there was never a man so notoriously abused. I am as well in my wits, fool, as thou art."
Stephen Fry in *Twelfth Night*, 4.2

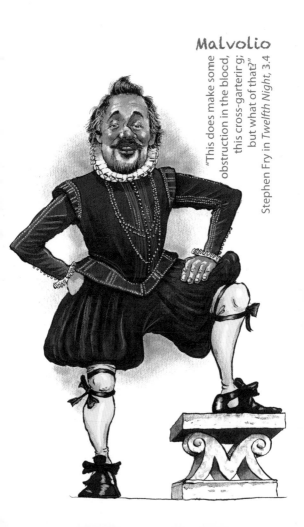

Malvolio

"This does make some obstruction in the blood, this cross-gartering; but what of that?"

Stephen Fry in *Twelfth Night*, 3.4

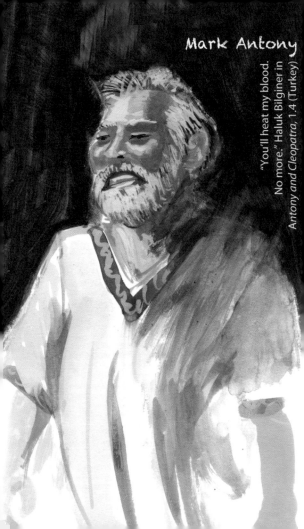

Mark Antony

"You'll heat my blood.
No more." Haluk Bilginer in
Antony and Cleopatra, 1.4 (Turkey)

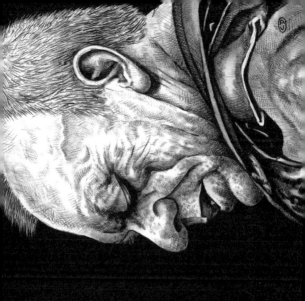

Mark Antony

"... now I'll set my teeth,
And send to darkness all that stop me."
Clive Wood in *Antony and Cleopatra,* 3.13

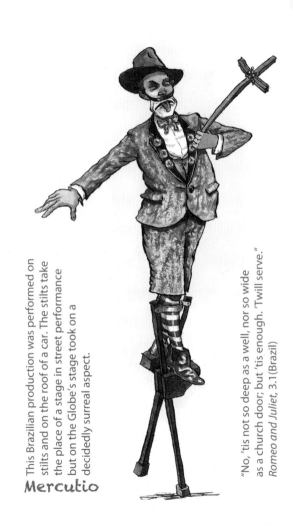

This Brazilian production was performed on stilts and on the roof of a car. The stilts take the place of a stage in street performance but on the Globe's stage took on a decidedly surreal aspect.

Mercutio

"No, 'tis not so deep as a well, nor so wide as a church door; but 'tis enough. 'Twill serve."
Romeo and Juliet, 3.1 (Brazil)

Mistress Overdone

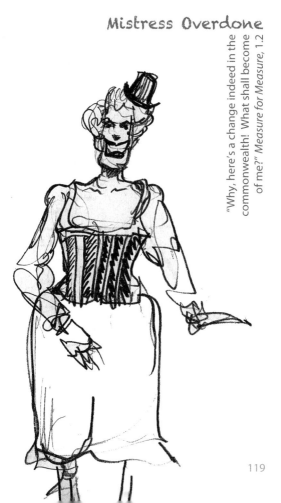

"Why, here's a change indeed in the commonwealth! What shall become of me?" *Measure for Measure*, 1.2

Mistress Page

"Why, I'll exhibit a bill in the parliament for the putting down of men... revenged I will be, as sure as his guts are made of puddings." *The Merry Wives of Windsor*, 2.1

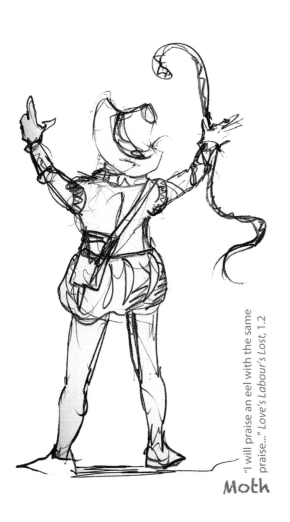

"I will praise an eel with the same praise..." *Love's Labour's Lost*, 1.2

Moth

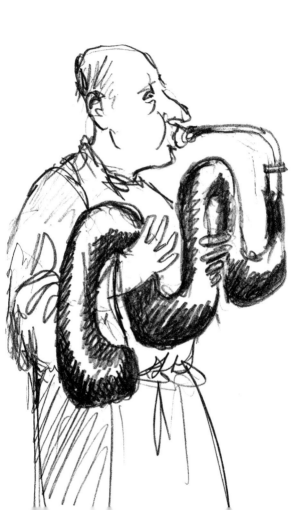

Mark the music

usic plays as important a part at today's Globe as it did during Shakespeare's time. He makes mention of music thousands of times and there are dozens of songs in the plays. Without much in the way of scenery or sophisticated lighting, music might be relied on to set the mood. Day or night, happy or sad, sacred or ceremonial, mysterious or familiar, emphasising love or conflict or maybe just a dance to entertain. Most Globe productions end with the cast sending the crowd home, happy and perhaps somewhat surprised, with a lively jig in which even the 'dead' rise to take part.

In many of the Globe to Globe productions the story was told through, and the productions joyously filled with, traditional folk music.

Sometimes the musicians are out of sight of the audience or in the gallery, the 'heavenly home' of the muses, or they might appear on-stage and in costume at the beginning of the play, entertaining the audience and then perhaps becoming part of the scene.

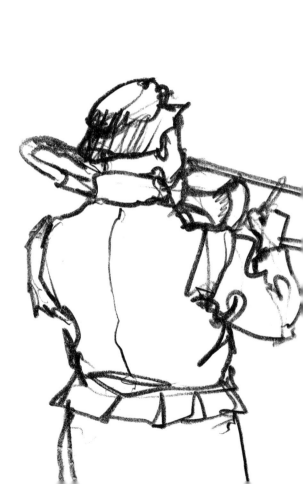

There is so much beautiful music from Shakespeare's time that is perhaps not as widely known as it deserves to be, with composers like Tallis, Dowland, Gibbons, Byrd, Morley and looking further afield, his near contemporary – the Italian, Monteverdi.

Music is very often played on original or period-style instruments like the rebec, a sort of early violin or the droning hurdy-gurdy, sackbuts, bagpipes, crumhorns, shawms, lutes, drums and even the astonishing serpent, whose name describes its appearance perfectly.

Today, composers like Claire van Kampen and William Lyons write original musical compositions for the theatre and a modern 'note' may find its way into the Elizabethan repertoire sound. Music at the Globe is not rigidly confined to a narrow time slot but allowed the freedom to do its magical job moving the plot along in both subtle and thrilling ways. The audiences seems to love it, reserving an extra cheer for the musicians at the end of a show.

"The man that hath no music in himself,
Nor is not moved with concord of sweet sounds,
Is fit for treasons, stratagems and spoils.
The motions of his spirit are dull as night
And his affections dark as Erebus:
Let no such man be trusted. Mark the music."
The Merchant of Venice, 5.1

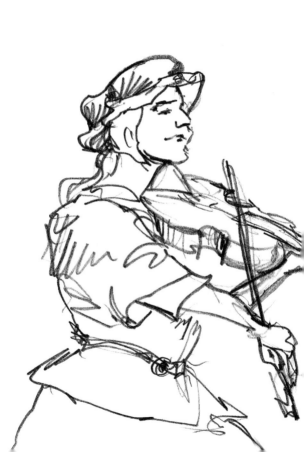

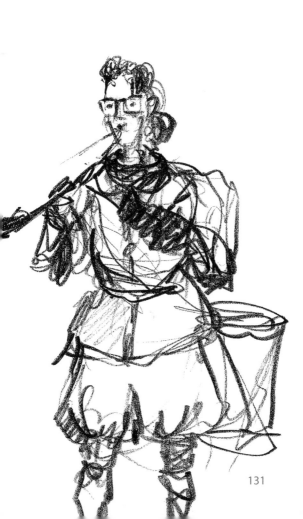

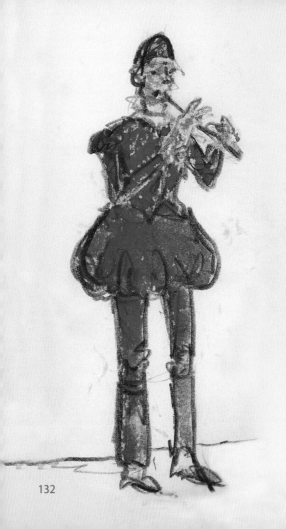

133

Narrator (Shakespeare), Capulet's Wife

Antonio Edson, Inês Peixoto in *Romeo and Juliet* (Brazil)

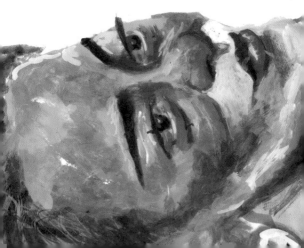

Splitting the air with noise.

One of the problems with open-air theatre is the noise from outside (it was the same in Shakespeare's time, with local industry and bear, bull and dog baiting going on nearby), but the sharp-witted actor can often get a laugh out of it. Here, the 'Mechanicals' are interrupted by the inevitable helicopter...

"...he goes but to see a noise that he heard, and is to come again." *A Midsummer Night's Dream,* 3.1

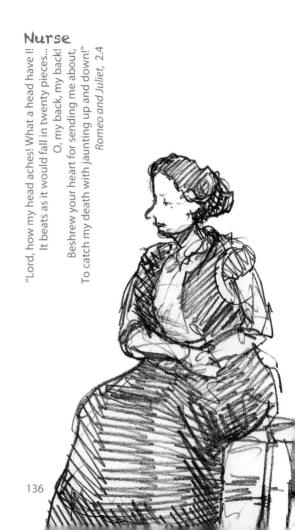

Nurse

"Lord, how my head aches! What a head have I!
It beats as it would fall in twenty pieces...
O, my back, my back!
Beshrew your heart for sending me about,
To catch my death with jaunting up and down!"
Romeo and Juliet, 2.4

Oberon and Puck

"Up and down, up and down,
I will lead them up and down.
I am fear'd in field and town.
Goblin, lead them up and down"
A Midsummer Night's Dream, 3.2

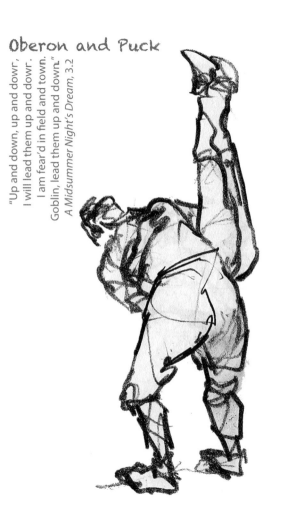

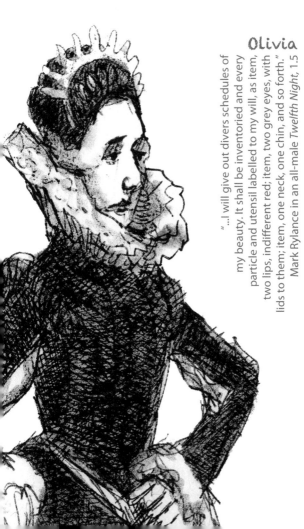

Olivia

"...I will give out divers schedules of my beauty. It shall be inventoried and every particle and utensil labelled to my will, as item, two lips, indifferent red; item, two grey eyes, with lids to them; item, one neck, one chin, and so forth."
Mark Rylance in an all-male *Twelfth Night*, 1.5

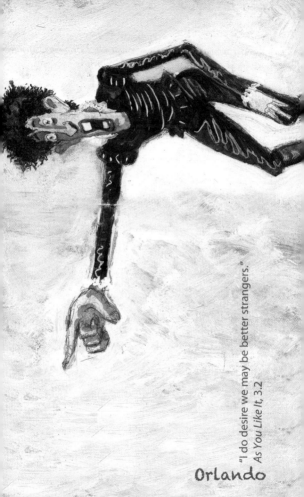

"I do desire we may be better strangers."
As You Like It, 3.2

Orlando

Othello

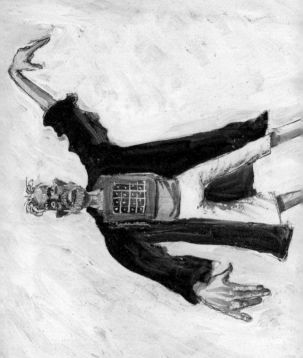

Pandarus

"What, blushing still? Have you not done talking yet?" *Troilus and Cressida,* 3.2

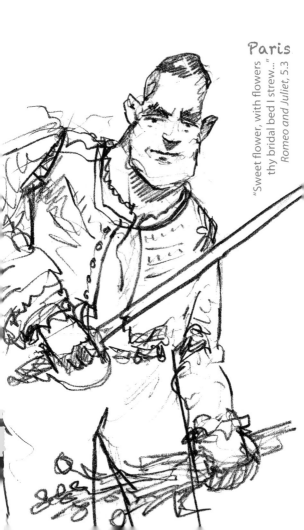

Paris

"Sweet flower, with flowers thy bridal bed I strew..."
Romeo and Juliet, 5.3

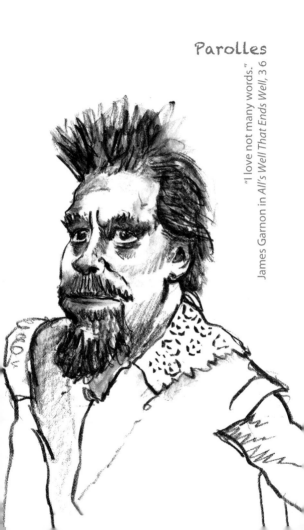

Parolles

"I love not many words."

James Garnon in *All's Well That Ends Well*, 3 6

Pericles

"Tis time to fear when tyrants seem to kiss..." *Pericles*, 1.2 (Greece)

144

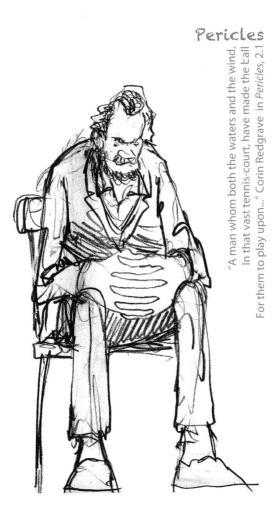

Pericles

"A man whom both the waters and the wind,
In that vast tennis-court, have made the ball
For them to play upon..." Corin Redgrave in *Pericles*, 2.1

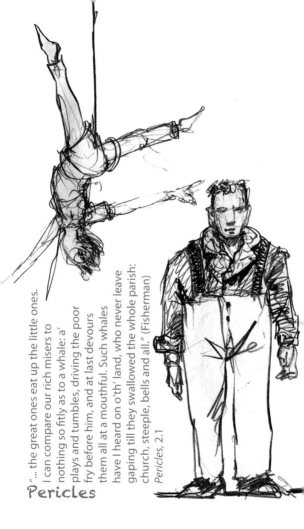

"… the great ones eat up the little ones. I can compare our rich misers to nothing so fitly as to a whale: a' plays and tumbles, driving the poor fry before him, and at last devours them all at a mouthful. Such whales have I heard on o'th' land, who never leave gaping till they swallowed the whole parish: church, steeple, bells and all." (Fisherman)

Pericles, 2.1

Pericles

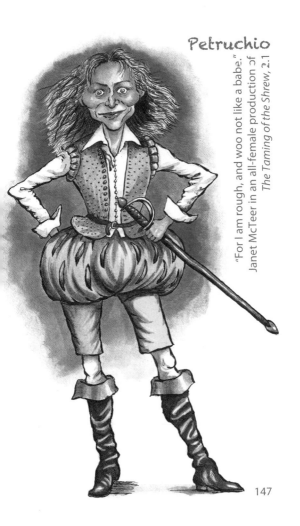

Petruchio

"For I am rough, and woo not like a babe."
Janet McTeer in an all-female production of
The Taming of the Shrew, 2.1

147

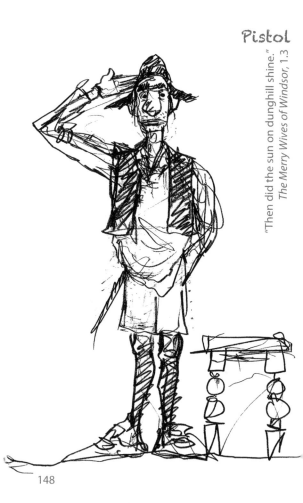

Pistol

"Then did the sun on dunghill shine."
The Merry Wives of Windsor, 1.3

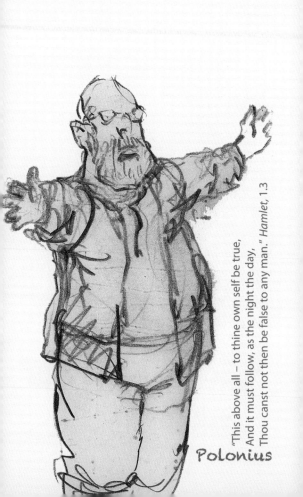

"This above all – to thine own self be true,
And it must follow, as the night the day,
Thou canst not then be false to any man." *Hamlet*, 1.3

Polonius

Porter

"... drink, sir, is a great provoker of three things.... nose-painting, sleep, and urine."
Macbeth, 2.3

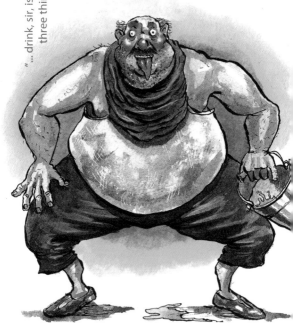

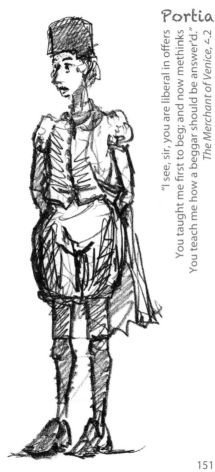

Portia

"I see, sir, you are liberal in offers
You taught me first to beg; and now methinks
You teach me how a beggar should be answer'd."
The Merchant of Venice, c.2

151

Princess of France

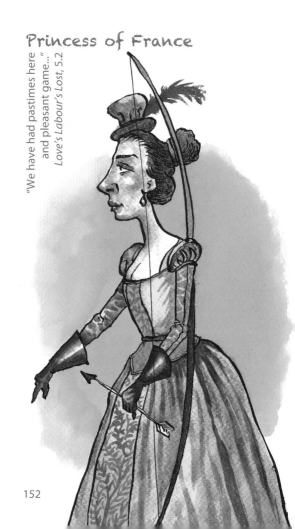

"We have had pastimes here and pleasant game..."
Love's Labour's Lost, 5.2

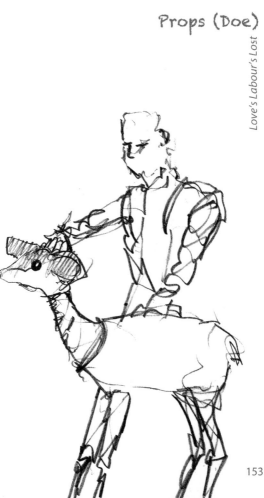

153

Giant Horse Skull

The Two Noble Kinsmen

Go get us properties and tricking for our fairies

The Globe relies a lot on the ambience of the building without the need for more elaborate sets, but the stage is constantly being transformed. Sometimes jutting out further into the arena with ramps and walkways, towers and masts, even buildings and gardens with ponds. The back wall boarded up into a fortress or draped in black or hung with drapes suggesting a forest or palace.

A walk past the several workshops in the Globe complex reveals the endless challenges the Props Department must face. Statues (some spouting water), carts, chariots, banners, flags, swords and spears, hedges, altars, thrones, prison gates, banqueting tables, incense burners and flaming torches, severed heads and masks. Flora and fauna: trees and flowers, rotting fish, boar chased by hounds, but also 'live' deer that seem to spring about the stage and convincing 'dead' deer to be carried in by hunters through the delighted or squeemish audience, and in *The Winter's Tale* I glimpsed just the arm of a bear lunging out from behind a curtain!

Lastly and very far from least there's all the Elizabethan-style make-up and costume so lovingly recreated, attested to in these pages.

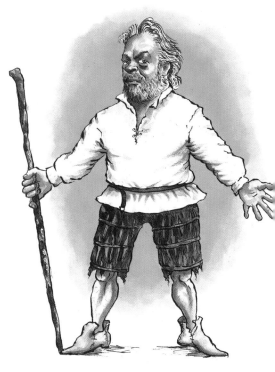

"But this rough magic
I here abjure... I'll break my staff,
Bury it certain fathoms in the earth,
and deeper than did ever plummet sound
I'll drown my book."
Roger Allam in *The Tempest,* 5.1

Prospero

156

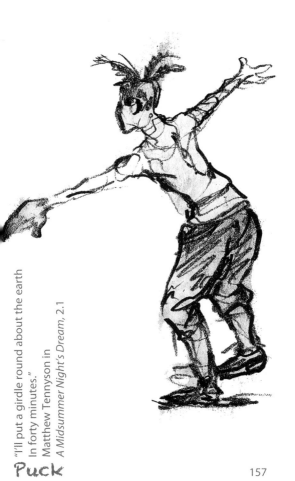

"I'll put a girdle round about the earth
In forty minutes."
Matthew Tennyson in
A Midsummer Night's Dream, 2.1

Puck

Richard II

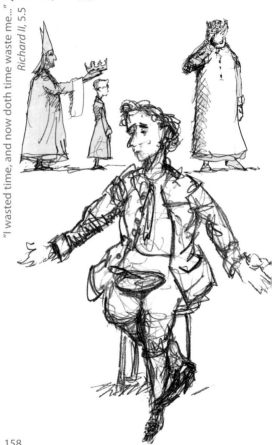

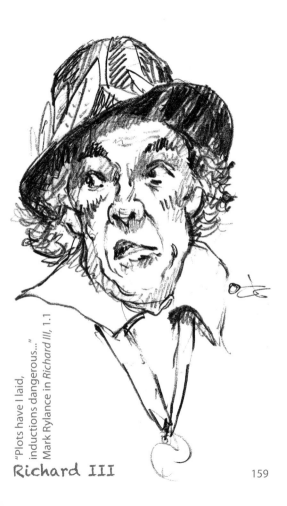

"Plots have I laid,
inductions dangerous..."
Mark Rylance in *Richard III*, 1.1

Richard III

159

Richard III

"I'll be at charges for a looking-glass,
And entertain some score or two of tailors,
To study fashions to adorn my body."
Kathryn Hunter in *Richard III*, 1.3

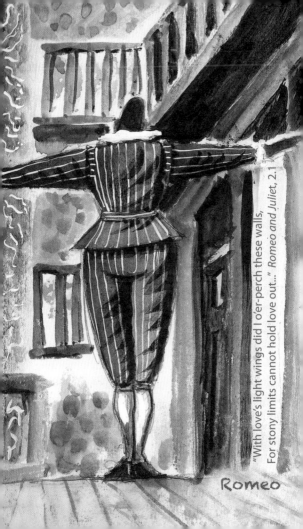

"With love's light wings did I o'er-perch these walls,
For stony limits cannot hold love out..." *Romeo and Juliet, 2.1*

Romeo

Rosalind

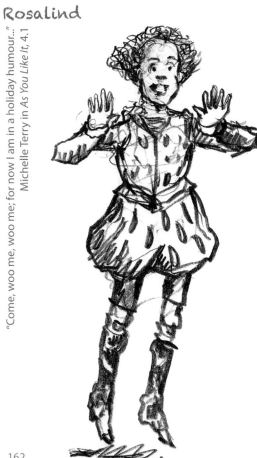

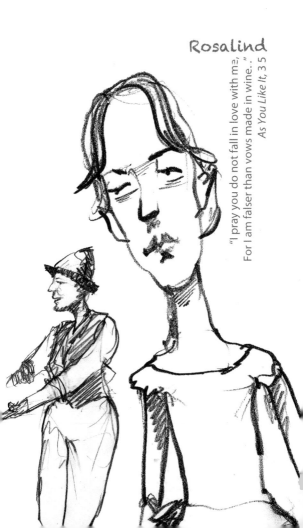

Rosalind

"I pray you do not fall in love with me,
For I am falser than vows made in wine."
As You Like It, 3 5

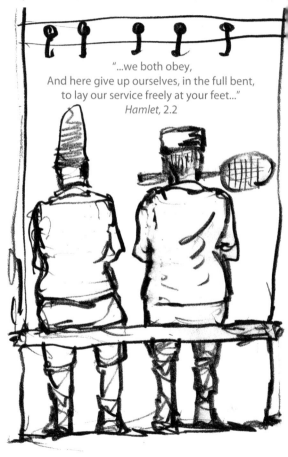

Rosencrantz and Guildenstern

"...we both obey,
And here give up ourselves, in the full bent,
to lay our service freely at your feet..."
Hamlet, 2.2

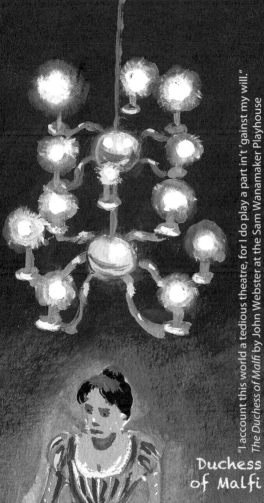

"I account this world a tedious theatre, for I do play a part in't 'gainst my will."
The Duchess of Malfi by John Webster at the Sam Wanamaker Playhouse

Duchess
of Malfi

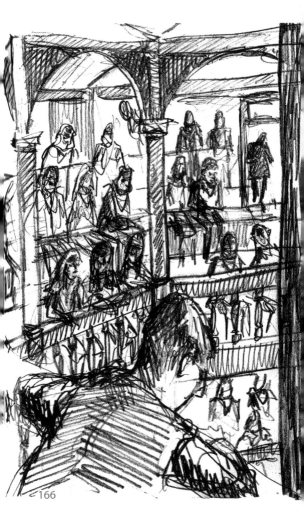

Mine eyes dazzle

n January 2014, the Globe opened the Sam Wanamaker Playhouse, an archetype of a Jacobean theatre based on drawings by John Webb, a student of Inigo Jones, found in the library of Worcester College, Oxford.

This beautiful building gives some idea of the earliest indoor theatres, perhaps even Shakespeare's own Blackfriars Playhouse that stood just across the river. Catering for a more affluent and arguably more sophisticated audience, the Blackfriars housed about 500 people who paid at least sixpence for admission.

The Sam Wanamaker Playhouse has room for 340 and seems quite compact inside – there's a feeling of eavesdropping on the players who are almost, or in some cases, actually within touching distance. There are seated places on cushioned benches in two galleries and a pit, with some standing places in the upper gallery. The structure of the auditorium is timber-framed, principally in oak, with decoratively-painted

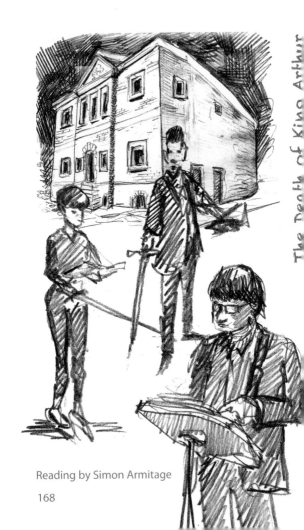

Reading by Simon Armitage

plaster panels, while the galleries and stage are finished in pine.

Astonishingly, it can be lit entirely by about a hundred candles in sconces and chandeliers or sometimes even held by the players. This is achieved, I believe through a triumphant collaboration of architectural research and strict fire regulations! The inviting smell is of new wood with honey from the beeswax candles.

Illuminated faces glow from the galleries surrounding the stage like a gathering about an open fire in a great hall. The actor Julian Glover and the poet Simon Armitage have read in the storytelling tradition, their versions of early English epics, *Beowulf, Sir Gawain and the Green Knight* and *The Death of King Arthur* receiving great acclaim in this new jewel box of a theatre.

The effect achieved by the lighting is more subtle than in the larger outdoor venue, the acting takes on a different tone – intimate, intense. Plays brought indoors from the Globe are played less broadly and the Jacobean tragedies written for such spaces become as dark and brooding as they should be.

It's also proving to be successful as a music venue, with classical, jazz, folk and world music on the menu. Once again you find yourself much closer to the performers than you would at most other concerts. Imagine being invited to someone's house to hear an opera!

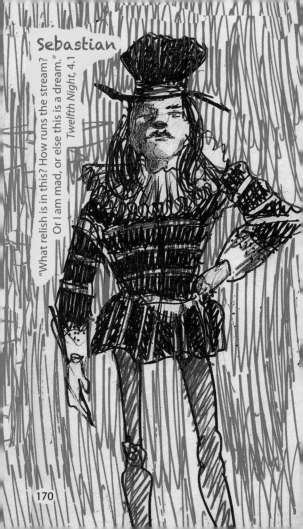

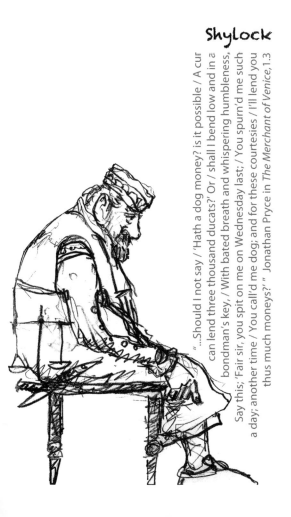

Shylock

"...Should I not say / 'Hath a dog money? is it possible / A cur can lend three thousand ducats?' Or / shall I bend low and in a bondman's key, / With bated breath and whispering humbleness, Say this; 'Fair sir, you spit on me on Wednesday last; / You spurn'd me such a day; another time / You call'd me dog; and for these courtesies / I'll lend you thus much moneys?'" Jonathan Pryce in *The Merchant of Venice*,1.3

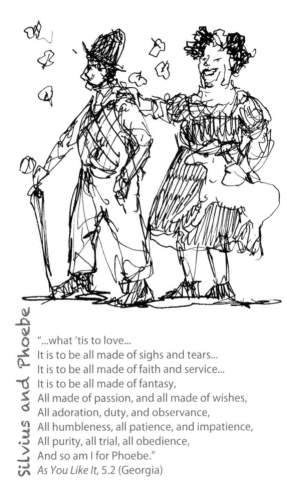

Silvius and Phoebe

"...what 'tis to love...
It is to be all made of sighs and tears...
It is to be all made of faith and service...
It is to be all made of fantasy,
All made of passion, and all made of wishes,
All adoration, duty, and observance,
All humbleness, all patience, and impatience,
All purity, all trial, all obedience,
And so am I for Phoebe."
As You Like It, 5.2 (Georgia)

Simonides

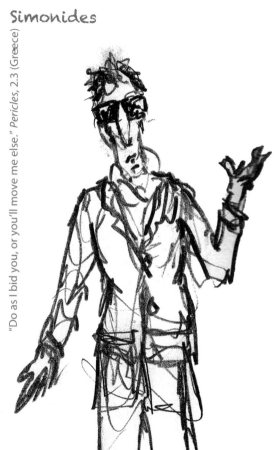

"Do as I bid you, or you'll move me else." *Pericles*, 2.3 (Greece)

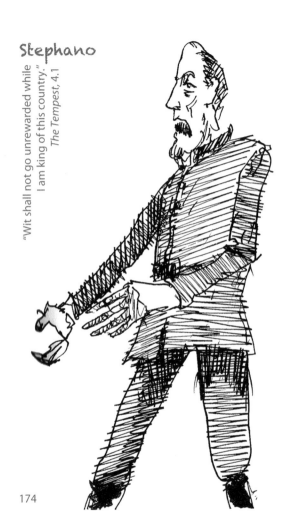

Stephano

"Wit shall not go unrewarded while I am king of this country."
The Tempest, 4.1

174

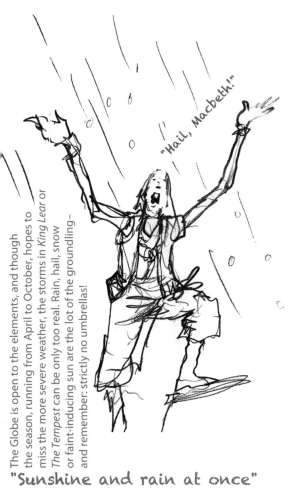

The Globe is open to the elements, and though the season, running from April to October, hopes to miss the more severe weather, the storms in *King Lear* or *The Tempest* can be only too real. Rain, hail, snow or faint-inducing sun are the lot of the groundling– and remember: strictly no umbrellas!

"Hail, Macbeth!"

"Sunshine and rain at once"

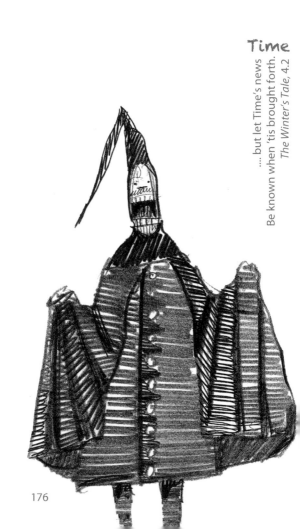

Time

... but let Time's news
Be known when 'tis brought forth.
The Winter's Tale, 4.2

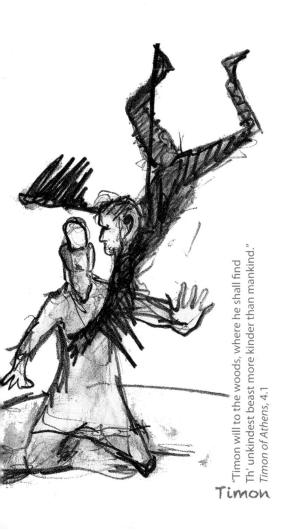

"Timon will to the woods, where he shall find
Th' unkindest beast more kinder than mankind."
Timon of Athens, 4.1

Timon

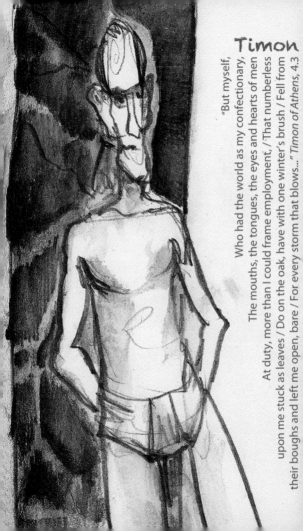

Timon

"But myself,
Who had the world as my confectionary,
The mouths, the tongues, the eyes and hearts of men
At duty, more than I could frame employment, / That numberless
upon me stuck as leaves / Do on the oak, have with one winter's brush / Fell from
their boughs and left me open, bare / For every storm that blows..." *Timon of Athens, 4.3*

Titus Andronicus

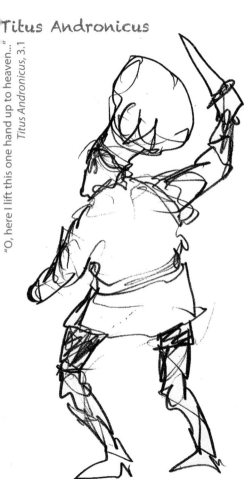

"O, here I lift this one hand up to heaven..."
Titus Andronicus, 3.1

179

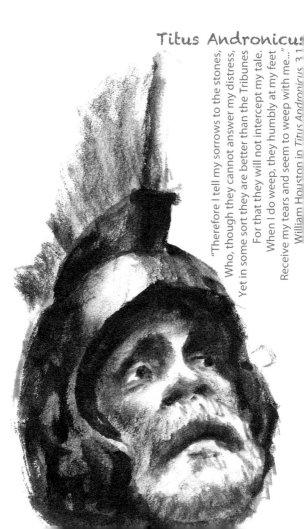

Titus Andronicus

"Therefore I tell my sorrows to the stones,
Who, though they cannot answer my distress,
Yet in some sort they are better than the Tribunes
For that they will not intercept my tale.
When I do weep, they humbly at my feet
Receive my tears and seem to weep with me..."
William Houston in *Titus Andronicus* 3.1

Titus Andronicus

"I am not mad; I know
thee well enough; / Witness
this wretched stump...; / Is not
thy coming for my other hand?"
Titus Andronicus, 5.2

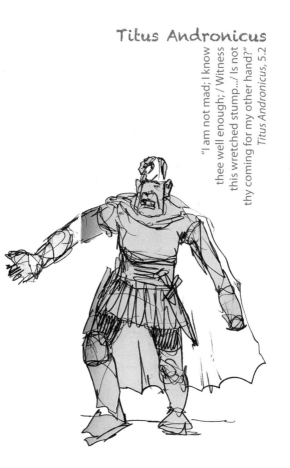

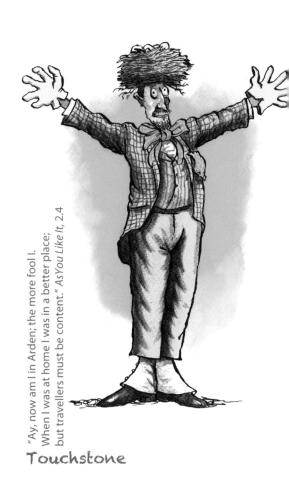

"Ay, now am I in Arden; the more fool I.
When I was at home I was in a better place;
but travellers must be content." *As You Like It*, 2.4

Touchstone

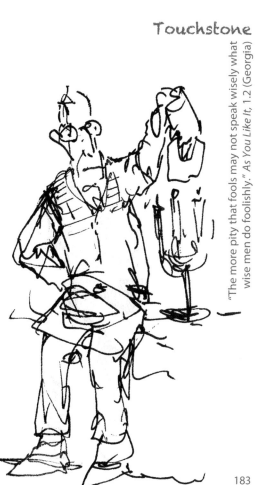

Touchstone

"The more pity that fools may not speak wisely what wise men do foolishly." *As You Like It*, 1.2 (Georgia)

183

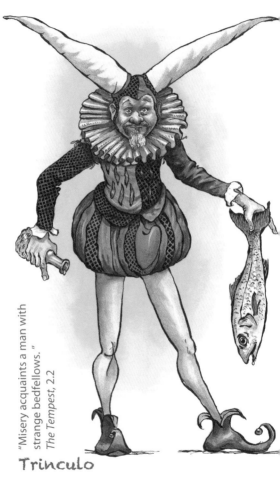

"Misery acquaints a man with strange bedfellows."
The Tempest, 2.2

Trinculo

"This is the monstruosity in love, lady, that the will
is infinite and the execution confined; that the
desire is boundless and the act a slave to limit."

Cressida

"They that have the voice of lions
and the act of hares, are they not monsters?"
Troilus and Cressida, 3.2

Troilus

Twelfth Night

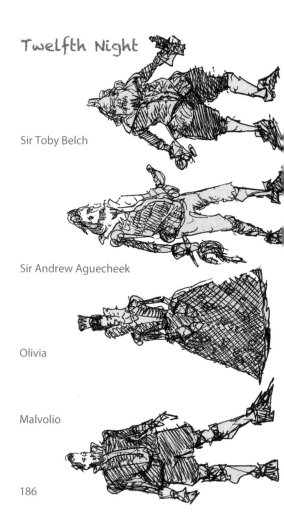

Sir Toby Belch

Sir Andrew Aguecheek

Olivia

Malvolio

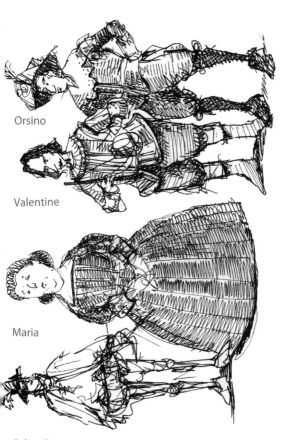

Orsino

Valentine

Maria

Sebastian

Venus

"The sun that shines from heaven shines but warm,
And, lo, I lie between that sun and thee.
The heat I have from thence doth little harm,
Thine eye darts forth the fire that burneth me,
And were I not immortal, life were done
Between this heavenly and earthly sun."
Venus and Adonis, 193-8
(South Africa)

" 'Fondling,' she saith, 'since I have hemmed thee here / Within the circuit of this ivory pale, I'll be a park, and thou shalt be my deer. Feed where thou wilt, on mountain or in dale; Graze on my lips, and if those hills be dry, Stray lower, where the pleasant fountains lie.' "

Venus and Adonis, 229

Venus

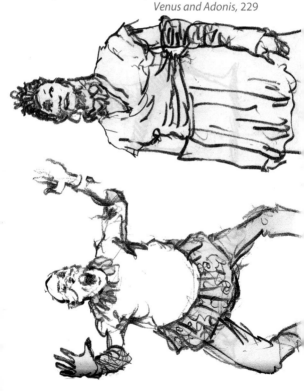

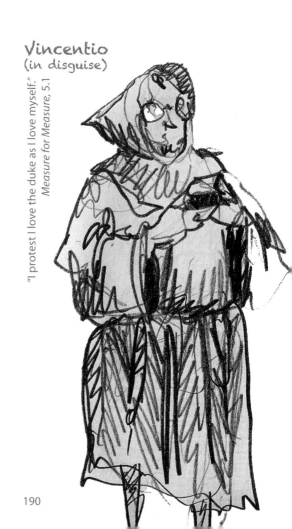

Vincentio
(in disguise)

"I protest I love the duke as I love myself."
Measure for Measure, 5.1

Vincentio

"Be absolute for death. Either death or life
Shall thereby be the sweeter."
Measure for Measure, 3.1

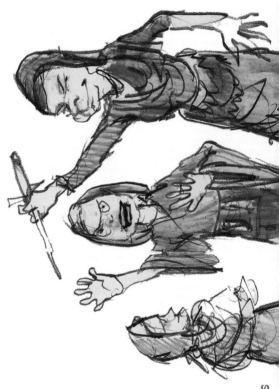

"But why
Stands Macbeth thus amazedly?"
Macbeth, 4.1

Witches

Exit, bearing a souvenir...

Copies of the plays, books (this book?), Tudor and other music, beeswax candles, life-size plastic skulls (Alas!), tee-shirts, hats, fridge magnets, lip-balm (!), wooden swords and cuddly plague rats (!!), or just this small plastic figure of Shakespeare might lay in wait for the souvenir-hunting visitor to the Globe shop.

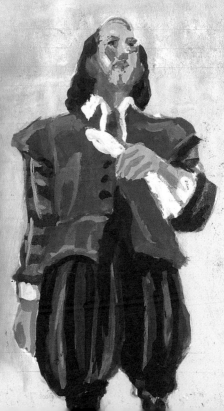

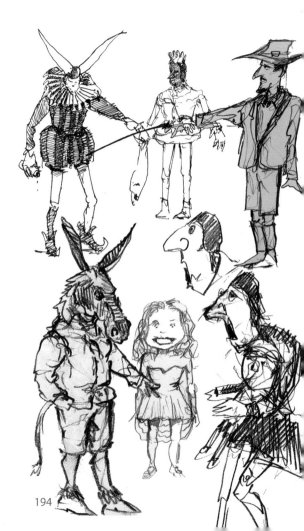

Chris Duggan

hris's pictures have appeared in many publications from Vogue to Punch, where for a time he was the cinema artist. He has worked for the Independent, Telegraph, FT, and is currently Business Cartoonist at The Times.

He has exhibited at The Showroom Gallery, the Political Cartoon Gallery, The Bank of England Museum, The Museum of National History (Les Invalides), Paris, The Coningsby Gallery ("2001, A Face Odyssey" – 2001 portraits), The Cartoon Museum, Greenwich Visitors Centre, Chris Beetles Gallery, Newport Museum and Art Gallery and Shakespeare's Globe Exhibition.

Some of his pictures are in the British Cartoon Archive, The Political Cartoon Gallery and Archer Political Cartoon Collection.

He has illustrated several books including *The Ascent of Rum Doodle, Hic! The Entire History of Wine* and *The Battle of the Colours.*

Unsurprisingly, he lives within cycling distance of the Globe Theatre.

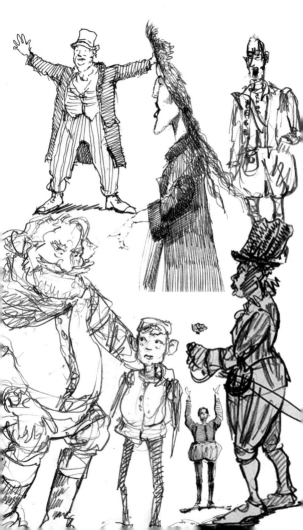

Dominic Dromgoole

Artistic Director of Shakespeare's Globe from 2006 to 2016, Dominic Dromgoole's productions in the Globe include *Julius Caesar, Hamlet, Gabriel* by Samuel Adamson, *A Midsummer Night's Dream, Hamlet, Henry IV Parts 1 and 2, A New World* by Trevor Griffiths, *Romeo and Juliet, King Lear, Love's Labour's Lost, Coriolanus,* and *Antony and Cleopatra.* His productions in the Sam Wanamaker Playhouse include *The Tempest, Pericles, The Changeling* by Thomas Middleton and William Rowley, and *The Duchess of Malfi* by John Webster.

He was Artistic Director of the Oxford Stage Company, 1999-2005, and of the Bush Theatre, 1990-6, and Director of New Plays for the Peter Hall Company, 1996-7. He has also directed at the Tricycle Theatre, in the West End, and in America, Romania and Ireland. He has written two books: *The Full Room* (Methuen, 2001) and *Will & Me* (Penguin, 2006) has had a column in the New Statesman and The Guardian, and has written extensively for many journals.

> "My recompense is thanks, that's all; Yet my
> good will is great, though the gift small."

Pericles, 3.4

Thanks... to Pete Le May at the Globe for being so patient and helpful in the original exhibition of these pictures, and being even more so in editing this book and for his invaluable advice on accuracy of content. Any remaining errors are all my own work.
...to Dominic Canty at Ancon Hill Publishing for encouragement, enthusiasm and all technical guidance and advice.
...to Dominic Dromgoole for taking time out of his busy schedule to write the foreword for this book and for all the great work he and and his predecessor, Mark Rylance have done at the theatre and indeed, all who have worked at the Globe and been my unknowing models.
...to Stuart John at The Printing House for his care in production.
...to my parents for first setting me on the Shakespeare trail.
...to my wife, Janet for ...everything.

You can buy a

signed print

of any of the pictures in this book. Printed with
ten colour UltraChrome HDR pigment archival
inks on William Turner, 310gsm, 100% rag content
watercolour paper with a beautiful, natural white
textured surface.

Price A4... £60, A3... £100
including post and packing
For contact details go to
cee-dee.com

Epilogue

Our revels now are ended. These our actors,
As I foretold you, were all spirits and
Are melted into air, into thin air,
And, like the baseless fabric of this vision,
The cloud-capp'd towers, the gorgeous palaces,
The solemn temples, the great globe itself,
Yea, all which it inherit, shall dissolve;
And, like this insubstantial pageant faded,
Leave not a rack behind.

The Tempest, 4.1